PHOTOGRAPHY
INDEX

PHOTOGRAPHY INDEX

A GUIDE TO REPRODUCTIONS

Compiled by Pamela Jeffcott Parry

GREENWOOD PRESS # 4491990
WESTPORT, CONNECTICUT • LONDON, ENGLAND

Library of Congress Cataloging in Publication Data

Parry, Pamela Jeffcott.
 Photography index.

 1. Photographs—Catalogs. I. Title.
TR199.P37 779'.01'6 78-26897
ISBN 0-313-20700-3

Library of Congress Catalog Card Number: 78-26897
ISBN: 0-313-20700-3

First published in 1979

Greenwood Press, Inc.
51 Riverside Avenue, Westport, Connecticut 06880

Printed in the United States of America

10 9 8 7 6 5 4 3 2

For
My Mother

Contents

Preface

Photography Index: A Guide to Reproductions is a reference tool intended to aid the user in locating reproductions of photographs, for the most part taken by professional photographers, dating from the earliest precursory attempts of the 1820s to works produced in the 1970s. It is based on the illustrations available in more than eighty major books and exhibition catalogs dealing with artistic, journalistic, and documentary photography. Part I is a chronological listing of works by unknown photographers; Part II is an alphabetical index to works by known photographers and photographic firms; and Part III is a detailed subject and title index which refers the user back to the first two sections for complete documentation and reproduction sources.

Types of Works Listed

The reproductions listed in this index are mainly of photographs considered to be artistic or documentary in nature and intent, although a fair sampling of other types of professional photography—news, fashion, scientific, etc.— has been included. Snapshots and other forms of amateur photography have generally been excluded, except for the period up to about 1880. The major focus of the index is on works by well-known photographers of the nineteenth and twentieth centuries, but a large number of more obscure figures have been included, as well as an ample selection of anonymous photographs, most dating from the nineteenth century. Mixed media works and photo-collages are included only if their makers also produced works that can be categorized as straight photography.

Information Given in the Index

In Part I, Chronological Index to Anonymous Photographs, entries are arranged by date and include title, date, and reproduction source. When the

year given for a photograph is a "circa" date, that listing precedes the photographs for which that year is firmly established, and the photographs for which only the year is established precede those dated by month and day as well.

In Part II, Index by Photographer, provides the most complete documentation and is arranged alphabetically by name of photographer or firm. Entries for individual photographs are then listed alphabetically by title, followed by collaborative (if there is more than one photograph with the same collaborator) and attributed works. Photographs of the photographer (other than self-portraits) are listed last. Entries include the following information:

1. Photographer—Name, alternative names, plus nationality and dates in most cases. Alternative names are cross-referenced.
2. Title of Work—Alternative or explanatory titles are given in parentheses following the first title, with the most complete or most frequently cited title given priority. Works with the same title and those labeled "Untitled" are arranged by date or, if they are part of a numbered series, by number.
3. Date of Work— Discrepancies between the dates given in different reproduction sources are noted.
4. Type of Photographic Media Used (if other than black-and-white print on bromide paper—e.g., daguerreotype, tintype, ferrotype, wet-collodion, platinum print, Polaroid, color print).
5. Publications in Which a Reproduction of the Photograph Appears— Books in which the work is pictured are indicated by a brief reference, usually the author's last name, which is amplified in the "List of Books Indexed." Also given are the page, plate, or figure number and, when appropriate, an indication that the reproduction is in color. Users are advised that many reproductions of photographs have been cropped for publication without this being so noted in the text or captions.

Books Indexed

The publications indexed were chosen to include a preponderance of recent, heavily illustrated works in English which would be available in most museum, college, or public libraries that contain art book collections. Emphasis is on books and exhibition catalogs that survey the history of photography in general or by period and/or country, or that focus on a particular medium (e.g., the daguerreotype or the stereo-photograph) or type of photography (e.g., photojournalism or landscape photography), and on catalogs of important collections of photographs. Monographs on individual photographers have not been included.

Subject and Title Index

Part III is meant to aid the user in locating photographs that depict a particular person, place, event, or theme (e.g., Farms and Farming or Nudes). The majority of entries are for photographs of individuals or geographical entities. Group portraits have been analyzed selectively. Portraits taken by a photographer of his or her relatives having the same last name are excluded from this section of the Index and are instead found in Part II. Portraits of photographers themselves are also listed only in Part II, unless the person is better known for his or her work in another field. Individual buildings (other than English and French country houses and chateaus), monuments, bridges, parks, etc., are listed under their locations. Photographs other than those of people or places are listed by title, if that title adequately and accurately describes their subject content, or under one or more of the over 100 subject headings, a list of which follows this preface. Under each subject, individual photographs are listed alphabetically by photographer, preceded by anonymous works, which are arranged by date. Entries in Part III give name of photographer, title, and date; users should then refer back to Parts I and II for reproduction sources.

PAMELA JEFFCOTT PARRY

List of
Subject Headings Used

(other than geographical, personal, and other proper names)

Aborigines
Afghan War, 1878-1880
Airplanes
Automobiles
Balloons
Baseball
Basketball
Bathers
Bats
Bears
Beauty Queens
Beggars
Biblical Themes
Birds
Boer War
Boxer Rebellion
Boxers and Wrestlers
Bridges
British Royal Family
Bull-Fighters and Bull-Fighting
Camels
Cats
Children (excluding posed
 portraits)
Chimpanzees
China War, 1856-1860
Churches
Circus
Civil War
Cowboys
Cows
Crimean War
Cyclists
Dancers and Dancing
Deer
Dogs
Dwarfs and Midgets
Elephants
Eskimos

Farms and Farming
Fires
Fish
Fishermen and Fishing
Floods
Flowers
Food
Football
Franco-Prussian War
Fruit
Funerals
Gas Stations
Gnu
Goats
Graves and Graveyards
Gypsies
Highlanders
Horse-Racing
Horses
Hospitals
Hunters and Hunting
Indian Mutiny of 1857
Indians (American)
Korean War
Ku Klux Klan
Literary Themes
Madras Famine, 1876-78
Maoris
Mexican War
Miners and Mining
Monks
Moon
Moose
Mormons
Motels
Mother and Child
Musicians
Mythological Themes
North-West Rebellion, Canada,
 1885

O = NOT FOUND
CARD
CATALOG
1/4/84

– = FOUND IN
CARD
CATALOG –
C.C. # LISTED

List of
Books Indexed

ACGB: Arts Council of Great Britain. The Real Thing: an Anthology of O
British Photographs, 1840-1950. London, The Council, 1975.
Aperture: French Primitive Photography. New York, Aperture, 1969. O
(Aperture, v.15, no.1)
Baltimore: 14 American Photographers. Baltimore, Baltimore Museum of –
Art, 1975. OVR TR 646 .U6 B343 1975
Beaton: Beaton, Cecil and Buckland, Gail. The Magic Image: the Genius –
of Photography from 1839 to the Present Day. Boston, Little Brown,
1975. OVR TR 139 .B42 1975b
Boston: Private Realities: Recent American Photography. Boston, Boston –
Museum of Fine Arts, 1974. OVR TR 646 .U6 B672 1974
Braive: Braive, Michael. The Art of Photography. New York, 1966. O
Buckland: Buckland, Gail. Reality Recorded: Early Documentary Photo-
graphy. Greenwich, Conn., New York Graphic Society, 1974. OVR TR 820 .5 .B8 1974 –
Camera: The World of Camera. Garden City, N.Y., Doubleday, 1964. O
Cameron: A Victorian Album: Julia Margaret Cameron and Her Circle. –
New York, Da Capo Press, 1975. OVR TR 681 .F3 V52 1975b
Coe: Coe, Brian. The Birth of Photography: the Story of the Formative
Years, 1800-1900. New York, Taplinger Pub. Co., 1976. OVR TR 15 .C59 1977 –
Coke: Coke, Van Deren. The Painter and the Photograph; From Delacroix –
to Warhol. Rev. and enl. ed. Albuquerque, University of New Mexico
Press, 1972. OVR N 72 .P5 .C6 1972
Coleman: Coleman, Allan D. The Grotesque in Photography. New York, –
Summit Books, 1977. OVR TR 686 .C64
Dennis: Dennis, Landt and Lisl. Collecting Photographs; a Guide to the O
New Art Boom. New York, Dutton, 1977.
Doherty: Doherty, Robert J. Social-Documentary Photography in the USA. O
Garden City, N.Y., AMPHOTO, 1976.
Doty-1: Doty, Robert. Photo Secession; Photography as a Fine Art. New O
York, George Eastman House, 1960.
Doty-2: Doty, Robert M. Photography in America. New York, Random –
House, 1974. OVR TR 23 .D67
Gernsheim-1: Gernsheim, Helmut. Creative Photography: Aesthetic O
Trends, 1839-1960. Boston, Boston Book and Art Shop, 1962.
Gernsheim-2: Gernsheim, Helmut and Alison. Creative Photography, 1826
to the Present. Detroit, Wayne State University Press, 1963. TR 6 .G5 –
Gernsheim-3: Gernsheim, Helmut. Masterpieces of Victorian Photography. O
London, Phaidon, 1951.

T-L-6: <u>Photojournalism</u>. New York, Time-Life Books, 1971.

Taft: Taft, Robert. <u>Photography and the American Scene: A Social
 History 1839-1889</u>. New York, Dover, 1964. TS 23 .T3 1964

Target: <u>The Target Collection of American Photography</u>. Houston, Museum
 of Fine Arts, 1976.

Thornton: <u>Masters of the Camera: Stieglitz, Steichen and Their Suc-
 cessors</u>. New York, Holt, Rinehart and Winston, 1976.

Topographics: <u>New Topographics: Photographs of a Man-Altered Land-
 scape</u>. Rochester, N.Y., International Museum of Photography at
 George Eastman House, 1975. TR 646.U6 R6

Tucker: Tucker, Anne, comp. <u>The Woman's Eye</u>. New York, Knopf, 1973. TR650 .T78 1973

UNC: <u>The American Situation: the Camera's Century</u>. Chapel Hill, N.C.,
 University of North Carolina, 1975.

V & A: Thomas, David Bowen. <u>"From Today Painting is Dead"-The Begin-
 nings of Photography</u>. (Catalog of an exhibition at the Victoria and
 Albert Museum) London, Arts Council, 1972.

Vision: <u>A Vision Shared; a Classic Portrait of America and Its People,
 1935-1943</u>. New York, St. Martin's, 1976.

Wise: Wise, Kelly, ed. <u>The Photographers' Choice: a Book of Portfolios
 and Critical Opinion</u>. Danbury, N.H., Addison House, distrib. by
 Light Impressions, Rochester, N.Y., 1975. OVR TR 650 .P47

Worcester: <u>Ideas in Images</u>. Worcester, Mass., Worcester Art Museum,
 1962.

Yale: <u>Four Directions in Modern Photography: Paul Caponigro, John T.
 Hill, Jerry N. Uelsmann, Bruce Davidson</u>. New Haven, Yale University
 Art Gallery, 1972.

Abbreviations

attrib.to	attributed to
b/w	black-and-white
col.	color
comp(s).	compiler(s)
det.	detail
ed.	editor
fig.	figure
illus.	illustration
n.d.	no date
n.p.	no page
no.	number
pl.	plate
prob.	probably
pub.	published
suppl.	supplement

PART I
Chronological Index
to Anonymous Photographs

4 *PHOTOGRAPHY INDEX*

Scharf-2, p.46
General Mejia
 Scharf-2, p.45
General Miramon
 Scharf-2, p.44
General 'Stonewall' Jackson
 Coe, p.75
Harrow Football Team
 Beaton, p.20
Head Housemaids and Manservant
 at Wilton House
 Beaton, p.16
Horace Greeley, albumen print
 Jareckie, p.22
An Itinerant Ferrotype Photo-
 grapher
 Coe, p.33
John Carbutt of Philadelphia
 Taft, p.365
John M. Stanley
 Taft, p.249
John Plumbe, Jr., daguerreotype
 Taft, p.47
Josiah Hawes, daguerreotype
 Taft, p.91
Julia Margaret Cameron
 Ovenden, p.8
The Ladies Revenging Insults on
 Crinoline, hand-colored ster-
 eo-card
 Jones, p.94 (col.)
Luxury, hand-colored stereo-card
 Jones, p.90 (col.)
Man Throwing Glass of Beer
 MOMA-5, p.117
Margaret Bourke-White
 Tucker, p.46
Maria Cecilia Tomlinson, da-
 guerreotype
 V & A, pl.4
May Morris, Daughter of Jane and
 William Morris
 Ovenden, pl.20
Melting Snow, Fountainbleau
 Coke, p.206
Moulin-Rouge
 Beaton, p.21
Mr. Moro Successfully Being Fro-
 zen in a Cake of Ice (Under-
 wood & Underwood)
 MOMA-4, p.53
Mrs. 'Skittles' Walters, Mistress
 of Edward, Prince of Wales
 Coe, p.75
A Nineteenth-Century French Pho-
 tographer and Friends Holding

Printing Frames
 Beaton, p.15
No.1 Engine, 'The Active'
 Jones, p.77
Nude Study
 Scharf-2, p.100
Nude Tableau, glass slide
 Jones, p.98
L'Oeil en Coulisse (The Glad
 Eye), glass slide
 Jones, p.99
Park Hotel, Colorado, stereo-
 scopic view
 UNC, pl.12
Park School for Girls
 Beaton, p.20
The Parthenon
 Coke, p.201
Peter Neff
 Taft, p.157
Photograph of an American Indian
 Made for Prince Roland Bona-
 parte
 L-S, pl.76
Pin-up Girl, hand-colored stereo
 -card
 Jones, p.98
Portrait of a Man
 Braive, p.77
Portrait of a Young Man, ambro-
 type
 Aperture, n.p.
Portrait of Bayard, daguerreo-
 type
 Beaton, p.11
Portrait of Delacroix
 Braive, p.118
A Punch Bowl with a Romantic
 History
 MOMA-4, p.15
Reverend Hannibal Goodwin
 Taft, p.399
S.N. Carvalho
 Taft, p.250
St. Anthony Falls, looking west,
 daguerreotype
 Rudisill, pl.80
Savage and Ottinger
 Taft, p.258
Scots with Royal Dogs
 Buckland, p.102
Standing Male Model
 Coke, p.82
360-Degree Panoramic Photograph
 of the Chicago Skyline
 Pollack, pp.454-55

PART II
Index by
Photographer

New York, West Side Looking
 North from Upper 30s, c.1936
 Monsen, p.88
Parabolic Mirror, Made of Many
 Small Sections, Reflecting One
 Eye
 Tucker, p.91
Princess Eugene Murat
 Tucker, p.83
Provincetown Playhouse, 133
 McDougal St., Manhattan,
 December 29, 1936
 Target, p.16
Roast Corn, Orchard and Hester
 Streets, Manhattan, 3 May 1938
 UNC, pl.34
Sylvia Beach, Paris, 1920
 Maddow, p.430
 Tucker, p.84
West Side, New York City
 Tucker, p.87

ADAL
 Cuarto que guarda recuerdos
 Coleman, p.197
 Paquete numero 825
 Coleman, p.198
 A Self-Defeating Gesture
 Coleman, p.196
 A Threat and a Promise
 Coleman, p.199

ADAM-SALOMON, Antoine Samuel
 French, 1811-1881)
 Alphonse Karr, c.1867, carbon
 print
 Gernsheim-5, pl.205
 Charles Garnier, c.1865
 Gernsheim-4, fig.98
 V & A, pl.12
 Jules Armand Stanislas Dujaure
 (from Galerie Contemporaine,
 Paris, 1878)
 Maddow, p.139
 Jules Verne, 1877, woodburytype
 Mathews, fig.156
 Lola Montez, c.1860
 L-S, pl.34
 Strasser, p.53
 The Sculptor Jouffroy, c.1858
 Braive, p.100
 Self-Portrait, c.1860
 Beaton, p.69
 Braive, p.128

ADAMS, Ansel (American, 1902-)
 Alfred Stieglitz in An American
 Place, 1938
 Newhall-3, p.176
 Aspens, Autumn, 1944
 Newhall-3, p.185
 Aspens, Northern New Mexico,
 1958
 MOMA-2, p.35
 Newhall-1, p.131
 Newhall-2, n.p.
 Autumn, Great Smokey Mountains
 National Park, Tennessee, 1948
 Pollack, p.365
 Clearing Winter Storm, Yosemite
 Valley, California, c.1944
 Doty-2, pp.128-29
 Courthouse, Mariposa, California,
 1934
 Newhall-3, p.173
 T-L-1, pp.214-15
 Edward Weston, 1950
 Newhall-3, p.180
 Ella Young, 1929
 Maddow, p.427
 Frozen Lake, Sierra Nevada (Fro-
 zen Lake and Cliffs, Sierra
 Nevada, California), 1934
 Doty-2, p.126
 MOMA-2, p.32
 Newhall-3, p.175
 T-L-3, p.215
 Georgia O'Keeffee and Orville
 Cox, Canyon de Chelly National
 Monument, Arizona, 1937
 Maddow, p.426
 House Near Carson City, Nevada
 Sixties, p.10
 Mendocino County, California,
 1950
 Newhall-3, p.177
 Mono Lake, California, 1944
 Newhall-3, p.181
 Monolith, The Face of Half Dome,
 Yosemite Valley, 1927
 Doty-2, p.127
 Pollack, p.368
 Moon and Half Dome, Yosemite
 National Park, California,
 1960
 Thornton, p.89
 Moon and Mount McKinley, 1948
 T-L-5, p.171
 Moonrise, Hernandez, New Mexico,
 1941
 Doty-2, pp.130-31

Jones, p.67
The Main Entrance of the Phila-
delphia Centennial, 1876
Taft, p.363
Moonlight on St. John's River,
Florida, 1886
L-S, pl.98
Steve Peere at Niagara, 1873,
stereograph
Greenhill, pl.83

BARNACH, Oskar (German, 1879-1936)
Self-Portrait, 1914
Braive, p.298

BARNARD, George N. (American,
1819-1902)
Burning Mills at Oswego, New
York, 1853, daguerreotype
Newhall-1, p.176
Newhall-4, pl.27
Rudisill, pl.48
Scharf-1, fig.2.12
City of Atlanta, Georgia (Atlan-
ta Burned by Sherman's Troops),
1865
L-S, pl.116
T-L-1, p.63
City of Atlanta, Georgia, Number
1, 1864
Doty-2, pp.32-33
Destruction of Hood's Ordinance
Train, 1864
Smart, p.15
Fortifications on Heights of
Centerville, Virginia, 1861-
65
MOMA-5, p.103 (detail)
Nashville From the Capitol,
albumen print
Jareckie, p.13
Rebel Works in Front of Atlanta,
Georgia, 1864
T-L-1, p.62
Rebel Works in Front of Atlanta,
Georgia, Number 1, 1864
Doty-2, p.35
Ruins of the Railroad Depot,
Charleston, South Carolina,
1865
Braive, p.228
Doty-2, p.34
Newhall-1, p.70
Scene of General McPherson's
Death (from Photographic Views
of Sherman's Campaign), 1864

or 1865, albumen print
MOMA-1, p.29
"The Woodsawyer's Nooning,"
1853
Newhall-4, pl.20
Rudisill, pl.95

BARNES
Apotheosis of Degas, 1870-75
Braive, p.262

BARNETT, E. Walter
Boer War Troop Train, Natal,
1899
Braive, p.244

BARNETT, H. Walter (Australian,
1862-1934)
Mrs. Saxton Noble, c.1908,
platinotype
Gernsheim-1, p.145
Sarah Bernhardt
L-S, pl.150

BARNUM, Deliss
Waterfall in the White Mountains,
c.1861
Naef, fig.27

BARRAUD, H. (active in London:
1880-1890)
Cardinal Newman, 1887, wood-
burytype
Gernsheim-3, pl.71
John Ruskin, c.1890
Strasser, p.75
Mrs. Gladstone, c.1890
Strasser, p.77

BARRETT, Arthur (British)
Suffragette Leaders in Dock at
Bow Street, London on 24 Oct.
1908: Christabel Pankhurst,
Mrs. Drummond, Mrs. Pankhurst
Gernsheim-4, fig.241
Gernsheim-5, pl.227

BARRETT, Michael (British)
The Inner Harbour, South Quay,
Lowestoft, c.1860
ACGB, pl.13

BARROW, Thomas F. (American,
1938-)
(From) Cancellation Series
(Brown) Pasadena Parallel,

Untitled (Prostitute Standing
 Before a White Dresser), c.
 1912
 Kahmen, pl.175
 UNC, pl.54
Untitled (Seated Woman in Tights),
 c.1912, printing-out paper
 Kahmen, pl.177
 Kansas, fig.14
 MOMA-1, p.69
 Maddow, p.267
Untitled, Storyville, New Or-
 leans, c.1912
 Maddow, p.265
Untitled, Storyville, New Or-
 leans, c.1912
 Maddow, p.266
Untitled, Storyville, New Or-
 leans, c.1912
 Maddow, p.268
(attributed to)
New Orleans, c.1905
 MOMA-5, p.34

BEMIS, Samuel (American, 1789-
1881)
 Boston, winter of 1840-41, da-
 guerreotype
 Rudisill, pl.9
 Crawford Notch, N.H., prob.1840,
 daguerreotype
 Rudisill, pl.12
 Crawford Notch, N.H., prob.1840,
 daguerreotype
 Rudisill, pl.13
 King's Chapel, Boston, 1840,
 daguerreotype
 Pollack, p.72
 King's Chapel Burying Ground,
 Boston, April 19, 1840
 Newhall-4, pl.3
 King's Chapel Burying Ground,
 Boston, winter of 1840-41,
 daguerreotype
 Rudisill, pl.10
 King's Chapel Burying Ground,
 Boston, winter of 1840-41,
 daguerreotype
 Rudisill, pl.11
 Tree in Farm Meadow, prob. near
 Crawford Notch, N.H., prob.
 1840, daguerreotype
 Rudisill, pl.14

BENDA, D'Ora See D'ORA

BENECKE, E. (French)
 (From) Voyage en Egypte et en
 Nubie, 1852, print from paper
 negative
 Aperture, nos.160-61

BENNETT, Gordon (American, 1933-)
 Store Window, Vallejo, 1968
 Lyons-3, p.76

BENNETT, Henry Hamilton (American,
 1843-1908)
 Among the Crags on Bluff, Wis-
 consin Dells, c.1870-73
 MOMA-2, p.14
 Canoeists in Boat Cave, Wiscon-
 sin Dells, c.1890-95
 MOMA-2, p.16
 In and About the Dells of Wis-
 consin River, on Top of Stand
 Rock, Wisconsin Dells, before
 1887
 UNC, pl.1
 Sugar Bowl with Rowboat, Wiscon-
 sin Dells, c.1889
 MOMA-1, p.45
 MOMA-2, p.15

BENSON, John (American, 1927-)
 Louie Looks Back at the World...
 ...And Discovers Paradise,
 1975
 Wise, pp.14-15
 Untitled, 1973
 Boston, pl.XIII (col.)
 Untitled, 1973, color print
 Boston, pl.XIV
 Untitled, 1973, color print
 Boston, pl.XV
 Untitled, 1973, color print
 Boston, pl.XVI

BENTLEY, W. A.
 Snow Crystals (from Marvels of
 the Universe, 1910)
 Scharf-2, p.243

BENTON, Stephen (American, 1941-)
 Cobweb Space, 1973, white light
 hologram, in collaboration
 with H. Casdin-Silver
 Light, p.18

BENY, Roloff (Canadian, 1924-)
 The Sacred Shrine of Mihintala,
 Ceylon, a Stairway Leading to

Sweet Water River, Na., No.75,
1859
Naef, fig.33
Sioux Village near Fort Laramie,
Na., No.72, 1859
Naef, fig.34

BIERSTADT, Charles (German-Ameri-
can, before 1832-1903)
Ice Bridge, Niagara Falls, c.
1867-70, albumen stereoscopic
prints
Monsen, p.61
Suspension Bridge, Niagara, New
York
Jareckie, p.23

BILL AND ILLINGWORTH (St.Paul,
Minnesota) See also ILLINGWORTH,
H.W.
Camp at White Bear Den, Dakota
Territory, 1866
Naef, fig.58
Captain Fisk's Expedition to
Montana, 1866; Forming the
Circle for a Night's Encamp-
ment
Taft, p.275

BINZEN, Bill
Untitled (Love), 1971
T-L-3, p.107 (col.)

BIOW, Hermann (German, 1810-1850)
Christian Gottfried Ehrenberg,
Chemist, Berlin, 1847
Maddow, p.40
Jakob Venedey, Member of Parlia-
ment for Homburg, 1848, da-
guerreotype
Gernsheim-5, pl.64
King Friedrich Wilhelm IV of
Prussia, 1847
Maddow, p.41
(attributed to)
Alexander von Humboldt, c.1850,
daguerreotype
Strasser, p.19

BIRTLES, J.
W.E. Gladstone Making a 'Whistle
-stop" Speech, 1885
Gernsheim-5, pl.271

BISCHOF, Werner (Swiss, 1916-1954)
Bolivian Boy, 1954

Gernsheim-4, fig.265 (col.)
Dhobis Flying in the Wind, Japan
Beaton, p.211
Easter Procession in Pisac,
Peru, 1954
Lyons-1, p.69
Famine in Madras Province, South
India, 1951
Gernsheim-1, p.223
Gernsheim-4, fig.260
Floods in East Hungary, 1947
Gernsheim-1, p.226
Hungarian Child
Camera, p.50
Mexico
Braive, p.351
Peruvian Piper, 1954
Pollack, p.470
Shinto Priests in Snow, Meiji
Temple, Tokyo, Japan, 1951
Gernsheim-4, fig.250
Newhall-2, n.p.
Pollack, pp.468-69
Sleeping Child Carried by His
Mother (Hongkong)
Camera, p.51
Snail Shells
Camera, p.154
Stepping-Stones in the Heian
Garden, Kyoto, 1952
Gernsheim-1, p.225
Study, 1941
Camera, p.20
Swiss Landscape
Camera, p.94

BISHOP, Michael (American, 1946-)
Untitled, 1967
Lyons-3, p.99
Untitled No.2306, 1974, RC print,
toned
Monsen, p.4

BISILLIAT, Maureen (American,
1931-)
(From) An Essay on Joao Guimar-
aes' Book, Grande Sertao, 1967
Lyons-3, p.62

BISSON FRERES (Louis-Auguste, b.
1814, and Auguste Rosalie, b.
1826) (French)
Ascension of Mont Blanc, 1860,
wet plate process
Pollack, p.121
Ascent of Mont Blanc, 1861
Braive, p.224

The Ascent of Mont Blanc-Halfway
 Point, c.1860, wet collodion
 Pollack, p.120
 Scharf-1, p.78
Entrance to the Valley of Cha-
 monix, 1860, wet-plate process
 Pollack, p.120
The Knight, Devil and Death
 (from Oeuvre d'Albert Durer
 photographie), 1854, paper
 print from glass negative
 Aperture, no.8
The Matterhorn, c.1865
 Mathews, fig.153
Mont Blanc and the Mer de Glace
 (View of the "Garden" from
 Mont Blanc), 1860, wet-plate
 process
 Gernsheim-4, fig.78
 Gernsheim-5, pl.174
 Pollack, p.121
On the Way Up, 1860 or 1861
 Buckland, p.48
Pyramide de l'Imperatrice, 1860
 T-L-1, pp.42-43
The Range of Mont Blanc, 1860,
 wet-plate process
 Pollack, p.121
The Summit of Mont Blanc from
 Chamonix, c.1861-63
 L-S, pl.41
Temple of Vespasian, Rome, De-
 tail of Architrave, 1858
 Gernsheim-1, p.48
 Gernsheim-5, pl.158
(attributed to)
 Portrait of Chopin, before 1849
 Braive, p.60

BLACK, James Wallace (American,
 1825-1896)
 Boston as the Eagle and the Wild
 Goose See It (Aerial View of
 Boston), Oct.13, 1860, in
 collaboration with S.A. King
 Scharf-1, p.109
 Taft, p.188
 John Brown, Abolitionist, winter
 of 1856-57, daguerreotype, in
 collaboration with J.A. Whip-
 ple
 Newhall-4, pl.99
 Winthrop Square, Boston, After
 the Great Fire of November 9th
 and 10th, 1872, albumen print
 Monsen, p.96

BLANCHARD, Stanley (American,
 1943-)
 Untitled, 1968
 Lyons-3, p.148

BLANCHARD, Valentine (British,
 1831-1901)
 Temple Bar, London, 1862, stere-
 oscopic photograph
 Gernsheim-5, pl.127

BLANQUART-EVRARD, Louis Desire
 (French, 1802-1872)
 Henri Victor Regnault, 1847
 Braive, p.218
 Hercules Recognizing Telephus,
 photograph of detail of a
 Herculaneum wall painting,
 Scharf-2, p.28

BLEASDALE, R. H.
 Wylam Willey, c.1856
 Coe, p.93

BLOCK, Lou
 Ben Shahn, 1934
 Vision, p.44

BLONDEAU, Barbara (American,
 1939-)
 Moving Nude, 1968
 Lyons-3, p.134

BLOOD, Ralph
 Portland Head Light (from Light-
 houses of the Maine Coast and
 the Men Who Keep Them)
 Coke, p.212

BLOOM, Suzanne See MANUAL

BLOSSFELDT, Karl (German, 1865-
 1932)
 Blumenbachia Hieronymi, Closed
 Seed-Pod, c.1930
 Kahmen, pl.234
 Blumenbachia Hieronymi, Open
 Seed-Pod, c.1930
 Kahmen, pl.231
 Cornus florinda, capitulum,
 c.1930
 Kahmen, pl.230
 Dipsacus Iaciniatus, #3, c.1920
 Dennis, p.63
 Melandryum noctiflorum, Seed-
 Pod, c.1930

Kahmen, pl.235
Michauxia campanuloides, c.1930
 Kahmen, pl.232
Seseli gummiferum, bract, c.
 1930
 Kahmen, pl.229
Silene vallesia, blossum, c.
 1930
 Kahmen, pl.233

BLOUNT, Sir Edward (British)
 Photo-montage, 1873
 Gernsheim-1, p.195

BLUE, Patt (American)
 Bill, April 1973
 Hayes, pl.48
 Chas, March 1973
 Hayes, pl.57
 Mortimer, Oct.1975
 Hayes, pl.58
 Walt, Nov.1972
 Hayes, pl.68

BLUMBERG, Donald (American,
 1935-)
 Untitled, 1965
 Lyons-1, p.86
 Untitled, 1966
 Lyons-4, p.18
 Untitled, 1968
 Lyons-3, p.66
(in collaboration with Charles
 Gill)
 Self-Portrait, 1967, air-brushed
 photo
 Lyons-4, p.9
 Untitled, 1966, photo-linen and
 acrylic
 Lyons-4, p.15
 T-L-3, p.147
 Untitled, 1966, photo-linen and
 acrylic
 Lyons-4, p.10
 Untitled, 1966, from a photo-
 graphic negative with drawing
 Lyons-4, p.11
 Untitled, 1966, from a photo-
 graphic negative with drawing
 Lyons-4, p.12
 Untitled, 1966, photo-linen and
 acrylic
 Lyons-4, p.16
 Untitled, 1966, photographic
 negative with drawing
 Lyons-4, p.17

Untitled, 1966, photo-linen and
 acrylic
 Lyons-4, p.19

BLUMENFELD, Erwin (German-
 American, 1900-)
 Face in Mirror, New York, 1944
 Coleman, p.171
 Hitler Skull, 1933
 Coleman, p.170
 Minotaure (or the Dictator),
 Paris, 1937
 Coleman, p.95
 Third Avenue El, 1951
 Pollack, p.429 (col.)
 Untitled
 Beaton, p.132 (col.)
 Untitled (from Verve)
 Beaton, p.159
 Untitled (from Verve)
 Beaton, p.160
 Wet Vail, 1937
 Coleman, p.94

BOCKRATH, Roger (American)
 San Rafael Breakout, 1970
 T-L-6, p.43

BOGARDUS, Abraham (American)
 J.H. Fitzgibbon, 1877
 Taft, p.249
 Samuel F.B. Morse and his Da-
 guerreotype Camera, 1871
 Taft, p.10
(Portraits of A. Bogardus)
 Abraham Bogardus, 1871, photo-
 grapher unknown
 Taft, p.328

BOGARDUS AND BENDANN BROTHERS
 Horace Greeley
 Coke, p.31

BOISONNAS, Fred (Swiss, 1858-1947)
 Coming Home from the Theatre,
 c.1902
 Gernsheim-1, p.133
 'Faust in His Study,' 1898
 Gernsheim-1, p.131

BOJE, Walter
 'The Tides,' Ballet with Music
 by Stravinsky, 1958
 Gernsheim-4, fig.273 (col.)

BOLDING, W. J. J. (British)
 Woman, Weybourne Village, Nor-
 folk, c.1850
 ACGB, pl.11

BONICELLI, Giovanni (Italian,
 1938-)
 The World of Children, No.2,
 1961
 MOMA-5, p.107

BOOLE, A. and J. (active in Lon-
 don c.1870)
 Lambeth Old House, Palace Yard,
 London, 1883, in collabora-
 tion with H. Dixon
 ACGB, pl.34
 Old Shop in Brewer Street, Lon-
 don, 1868
 Kahmen, pl.88
 (attributed to; also to H. Dixon)
 The Oxford Arms, London, 1875
 L-S, pl.108

BORNTRAEGER, Carl
 Wiesbaden, Man in a Studio Mock
 -up of a Railway Carriage,
 1860s
 L-S, pl.156

BORODAC, Ladislaus (Czechoslo-
 vakian, 1933-)
 Figural Composition #5, 1968
 Lyons-3, p.130

BOSHIER, Derek (British, 1937-)
 Routes 2/13/12 (no.12 Vancouver,
 Canada), March 1975
 Graz, p.30 (col.)
 Routes 5/10/3/11 (no.10 King-
 ston, England), Nov.1974
 Graz, p.31 (col.)
 (Portraits of Derek Boshier)
 Derek Boshier, photographer
 unknown
 Graz, p.32

BOSSHARD, Walter (Swiss, 1892-)
 Gandhi Eating Onion Soup, pub.
 1929-30
 Gidal, p.33
 Gandhi Reading a Satirical Eng-
 lish Poem About Himself, pub.
 1929-30
 Gidal, p.33
 Gandhi Taking a Midday Nap, pub.

 1929-30
 Gidal, p.33
 Kumbum, the City of Three Thou-
 sand Monks in China: Evening
 Meditation, pub.1934
 Gidal, p.36
 Kumbum, the City of Three Thou-
 sand Monks in China: Medical
 Exams in Individual Cells,
 pub.1934
 Gidal, p.36
 Kumbum, the City of Three Thou-
 sand Monks in China: The Pro-
 fessor of Medical Science and
 Morals, pub.1934
 Gidal, p.36
 The Man who Challenged the
 British Empire: Mahatma Gand-
 hi Reading, pub.1930
 Gidal, p.32
 Polar Flight with the Zeppelin
 After Umberto Nobile's Unsuc-
 cessful Expedition, pub.1931
 Gidal, pp.34-35
 Sanju-Dawan Pass, Oct.18, 1929
 Gidal, p.31
 Yaks as Beasts of Burden, 1927-
 29
 Gidal, p.31
 The Zeldar of Saktis, 1927-29
 Gidal, p.31

BOUBAT, Edouard (French, 1923-)
 Chicken and Tree, 1951 (France,
 1959)
 Kahmen, pl.72
 MOMA-1, p.153
 In Bethlehem
 Camera, p.41
 Lella, 1959
 Beaton, p.179

BOURDEAU, Robert (Canadian,
 1931-)
 Untitled (Dark Trees Against
 Field of Bare Branches), 1975
 Wise, p.118
 Untitled (Dead and Broken Trees
 in Clearing), 1975
 Wise, p.119
 Untitled (Outcropping of Rock),
 1975
 Wise, p.118
 Untitled (Pond), 1975
 Wise, p.121
 Untitled (Scrap Metal), 1975

BREAKWELL, Ian (British, 1943-)
 Growth, 1969-73, photograph album
 in perspex box
 Graz, pp.40-41
 Repertory, 1974, photo-silk-
 screen prints
 Graz, pp.38-39
 (Photographs of Ian Breakwell)
 Ian Breakwell, photographer un-
 known
 Graz, p.42

BREIL, Ruth (American)
 Cowboy, Campo de Gato, Bahia,
 summer 1972
 Hayes, pl.21
 Cowboy with Star Hat, Bahia,
 summer 1972
 Hayes, pl.22
 Giora in Brasilia, summer 1972
 Hayes, pl.113

BREITNER, Georg-Hendrik (Dutch)
 Three Young Girls, c.1895
 Coke, p.88
 Wheelbarrow Men, c.1895
 Coke, p.88

BRIDGES, Rev. George (British)
 The Sphinx, Noon 15 January 1851
 ACGB, pl.3
 Taormina, c.1851, calotype
 Coe, p.84

BRIDSON, J.
 Picnic, c.1882
 Gernsheim-1, p.116
 Gernsheim-3, pl.65
 Gernsheim-4, fig.144
 Gernsheim-5, pl.233

BRIGMAN, Annie W. (American, 1869-
1950)
 The Cleft of the Rock. c.1912,
 pub.1912 in Camera Work
 Doty-1, pl.XXIV
 Green, p.157
 The Dream, c.1906
 Coe, p.123
 The Hamadryads, n.d.
 SFMA, n.p.
 Sand Erosion, 1931, intaglio
 Lyons-1, p.27

BRITT, Peter
 Jacksonville, Oregon, c.1854-55,

daguerreotype
 Rudisill, pl.77

BROGI, Giacomo (Italian)
 La Galleria Vittorio Emanuele,
 Milano, stereo-card
 Jones, p.61
 Milano. Interno dell'Ospedale
 Maggiore
 Jones, p.60
 Spires and Buttresses of Milan
 Cathedral
 Jones, p.60

BRONNER (active in Richfield
 Springs, N.Y.)
 Henry T. Anthony
 Taft, p.392

BROOK, John (American, 1924-)
 Untitled
 Sixties, p.11

BROOKS, Ellen (American, 1946-)
 Untitled, n.d., cyanotype on
 fabric/quilt
 Light, p.10

BROOKS, Reva (Canadian, 1913-)
 The Dead Child, San Miguel de
 Allende, Mexico, c.1960
 SFMA, n.p.

BROWN, Dean (American, 1936-1973)
 California Cows, 1969
 Doty-2, p.201 (col.)
 Mannequin, 1971
 T-L-3, pp.86-87 (col.)
 Martin Luther King, Funeral,
 #1-17a, 1968, transparency-
 overlay
 Lyons-3, p.80
 Red Striped Hills, 1969
 Doty-2, p.200 (col.)

BROWN, Robert E. (American,
 1937-)
 Door, 1973, photo mural
 Light, p.11
 Untitled, 1967, transparency
 Lyons-3, p.146

BROWN, Thomas
 Kitchen, 1968
 T-L-3, p.122

BROWN, Vernon
 U.S. Coastguard: Omaha Beach,
 1944
 T-L-5, pp.216-17

BROWN, W. Henry (active in Santa
 Fe, New Mexico)
 Burro Alley, Santa Fe, c.1875
 Naef, fig.105
 Starvation Rock (New Mexico),
 c.1875
 Naef, fig.104

BROWNE, John C. (active in Phila-
 delphia)
 Edward L. Wilson and the Rev.
 H.J. Morton, Oct.26, 1865
 Taft, p.202
 Generals Burnside and Anderson,
 summer 1865
 Taft, p.381
 Old Mill, May 1870
 Taft, p.318

BRUDER, Harold (American, 1930-)
 Sewing on a Summer Day, 1962
 Coke, p.119

BRUGUIERE, Francis (American,
 1880-1945)
 Girl in a Room, 1930
 Rotzler, pl.82
 Hands, c.1930
 Doty-2, p.107
 The Heart Rejoices at Release,
 c.1925
 Doty-2, p.107
 Light Abstraction
 Beaton, p.143
 Light Abstraction, c.1925
 Newhall-1, p.164
 Light Abstraction, 1928-30
 Rotzler, pl.78
 Light Abstraction, 1928-30
 Rotzler, pl.81
 Light Abstraction Based on a
 Question Mark, c.1929
 Rotzler, pl.79
 Rosalind Fuller with her Cello,
 1930, multiple exposure
 Rotzler, pl.77
 St. George and the Dragon, un-
 dated photodrawing
 Rotzler, pl.80
 Solarization, c.1925
 Lyons-1, p.17

BUBLEY
 Memorial Day, Arlington Cemetery,
 Virginia, 1941
 Stryker, pl.28

BUCHARD, Jerry (American, 1931-)
 Rochester, Xmas, 1975
 Target, p.14

BUCKLAND, David
 Salience
 Beaton, p.224 (col.)

BUCKLEY, Peter (American, 1925-)
 The Bull Attacks, Bilbao, 1951
 MOMA-5, p.56
 Bullfight Critic, Logrono, 1956
 MOMA-5, p.153
 Manoletina Pass, Bilbao, 1957
 MOMA-5, p.118
 Matador Circling the Ring in
 Triumph, Bilbao, 1956
 MOMA-5, p.137

BUCQUET, Maurice (French, c.1921)
 Effet de Pluie, Paris, c.1899
 Gernsheim-1, p.140
 Gernsheim-4, fig.163
 Gernsheim-5, pl.291

BUDNIK, Dan
 Bruce Davidson, 1959
 Lyons-2, p.9
 Forest of Versailles, 1960
 Pollack, p.426 (col.)
 Paris, 1961, color photograph
 Lyons-1, p.99
 Portrait of a Young Girl
 Camera, p.25

BUEHMAN, H. (active in Tucson,
 Arizona)
 Panorama of Tucson, Arizona,
 c.1875
 Naef, fig.106

BUELL, O. B. (American)
 Riel Addressing the Jury in
 Court House, Regina, 1885
 Greenhill, pl.104

BULLOCK, Wynn (American, 1902-)
 Barbara, 1956
 Wise, p.147
 Child in the Forest, 1954
 T-L-5, p.149

BURROWS, Larry (British, 1926–
1971)
First-Aid Centre During Opera-
tion Prairie, Vietnam, 1963
Beaton, p.217 (col.)
Vietcong Captives in the Mekong
Delta, 1963
Beaton, p.216

BURTON, Alfred H. (active in New
Zealand, 1834–1914)
Maori Man, with Tall Hat and
Feather, c.1878
L-S, pl.79

BUSHMAN, Naomi (American)
Untitled
Kalmus, p.4

BYRON, Joseph (British-American,
1846–1922)
Madison Square, Looking South
from about 24th Street, 1901,
in collaboration with P.C.
Byron
Beaton, p.125

BYRON, Percy Claude (British-
American, 1879–1959)
Madison Square, Looking South
from about 24th Street, 1901,
in collaboration with J. Byron
Beaton, p.125
Richard Hall at work on his por-
trait of Cathleen Neilson (the
future Mrs. Reginald Claypoole
Vanderbilt), 1902
Maddow, pp.274–75

CADE, Robert
Frederick Scott Archer, 1855,
ambrotype
Gernsheim-5, pl.95

CAGNONI, Romano
Soldiers, Biafra, 1968
T-L-3, p.191

CAKEBREAD, Jack
South Shore, 1968
T-L-5, p.188

CALDESI (Italian; active in Lon-
don)
The Royal Family at Osborne,
1857
Buckland, p.96

CALLAHAN, Harry (American, 1912–)
Airplane Hanger, c.1955
Pollack, pp.538–39
Bob Fine, 1952
T-L-3, p.184
Chicago, 1949
Kahmen, pl.300
Chicago, 1950
T-L-1, p.221
Chicago, c.1960
Thornton, pp.208–09
Chicago Loop, 1952, multiple
exposure
Pollack, p.535
Cuzco, Peru, 1974
Thornton, p.211
Dearborn Street, Chicago, c.
1953
Pollack, p.532
Detroit, 1941
MOMA-2, p.37
Detroit, 1943
MOMA-5, p.107
Eleanor, 1948
Gernsheim-4, fig.233
Newhall-2, n.p.
Thornton, pp.206–07
Eleanor, 1948
Beaton, p.256
Doty-2, p.186
T-L-5, p.151
Eleanor, 1951
Lyons-1, p.72
Eleanor and Barbara, Chicago,
1954
Maddow, p.464
Eleanor, Chicago, 1949
Maddow, p.463
Eleanor, Port Huron, 1954
MOMA-1, p.167
Facade, Wells Street, Chicago,
1949
Monsen, p.90
Grass, Aix en Provence, France,
1958
Newhall-2, n.p.
Grasses in Snow, Detroit, 1943
Thornton, pp.204–05
Heroic Figure, Chicago, 1961
MOMA-5, p.134

Cameron, pl.60
Ovenden, pl.63

CAMERON, Julia Margaret (British,
1815-1879)
Alfred, Lord Tennyson, July 4
 Newhall-2, n.p.
Alfred, Lord Tennyson, 1865
 Newhall-3, p.48
Alfred Lord Tennyson, June 1869
 Gernsheim-3, pl.48
 Mathews, fig.102
 Pollack, p.168
Alfred Tennyson (The Dirty Monk),
 1865, wet-collodion
 Cameron, pl.18
 L-S, pl.26
 Scharf-1, fig.4.2
Alfred Tennyson with sons Lionel
 and Hallam, c.1864
 Maddow, p.125
Alice Liddell (Pomona), c.1870,
 wet-collodion
 Maddow, p.131
 Ovenden, pl.55
 Scharf-1, fig.4.1
Alice Liddell, 1872
 Beaton, p.67
 Hannavy, p.69
 Ovenden, pl.27
Allegorical Group, c.1868
 Cameron, pl.39
And Enid Sang (illustration for
 Tennyson's Idylls of the King),
 1875
 Beaton, p.65
 Ovenden, pl.42
The Angel at the Sepulchre, c.
 1868-72, sepia photograph
 Gernsheim-3, pl.54
 Mathews, fig.106
 SFMA, n.p.
The Angel at the Tomb (Mary
 Hillier), c.1872
 Ovenden, pl.36
Annie Chinery, 1869
 Cameron, pl.21
Annie Chinery, 1869
 Cameron, pl.37
Annie, My First Success (Annie
 Philpot), Jan.1864, wet-
 collodion
 Cameron, pl.97
 Scharf-1, p.68
Aubrey de Vere, c.1865
 Cameron, pl.46

Beauty of Holiness, c.1865-66
 Cameron, pl.112
Cassiopeia, 1866
 MOMA-5, p.30
Charles Darwin, c.1868
 V & A, pl.17
Charles Darwin, 1869
 Maddow, p.123
 Mathews, fig.103
 Pollack, p.167
Charles Darwin, 1869
 Gernsheim-3, pl.53
Charles Darwin, 1869
 Gernsheim-4, fig.103
Charles Hay Cameron, c.1865
 Cameron, pl.44
Charles Hay Cameron (Jr.),
 c.1866, carte-de-visite
 Cameron, pl.67
Cherub and Seraph, c.1864
 ACGB, pl.19
Child Drawing, c.1870
 Mathews, fig.107
Circe, n.d.
 T-L-1, p.73
'La Contadina'
 Hannavy, p.53
Cupid, 1866
 Cameron, pl.85
Daisy, 1864
 Cameron, pl.24
The Day Dream (The Dream), April
 1869
 Cameron, pl.23
 Hannavy, p.69
 Ovenden, pl.27
Devotion, 1865
 Cameron, pl.89
Divine Love, c.1865
 Cameron, pl.17
The Echo, c.1868
 Cameron, pl.82
Eleanor Locker (later Mrs.
 Lionel Tennyson), 1869
 Maddow, p.125
Ellen Terry, 1864
 Gernsheim-1, p.66
 Newhall-3, p.51
 Pollack, p.170
 Strasser, p.59
Ewan's Betrothed, 1869
 Cameron, pl.80
Florence, 1872
 Gernsheim-1, p.84
 Ovenden, pl.44
Florence, 1872

64

c.1907, pub. 1908 in Camera
Work
 Green, p.241
 Lyons-1, p.5
Unknown Sitter
 Beaton, p.107
Untitled
 Beaton, p.109
Vaslav Nijinsky in Le Pavillon
d'Armide
 Beaton, pp.295-96
A Wedding Dress, Modeled by Helen
Lee Worthing, 1920
 Newhall-1, p.185
Woman with Cup, c.1910
 T-L-4, p.108
Woman with Oriental Plant, n.d.
 T-L-4, p.109

DENA (Finnish-American)
Esteban Vicente (painter), 1970
 Kalmus, p.107
Norman Mailer, Provincetown,
1965
 Kalmus, p.11

DESAVERY, Charles (French)
Corot at Arras, 1871
 Coke, p.52

DETRICK, Len
For Posterity (Mrs. Frank Sina-
 tra...gave birth to Frank,
 Jr.), Jan.12, 1944 (Daily News)
 MOMA-4, p.61

DIAMOND, Hugh W. (British, 1809-
1886)
Mental Patients, c.1850-53
 Mathews, figs.23-26
Mental Patient, c.1852-55
 Buckland, p.75
Mental Patient, c.1852-56
 Beaton, p.48
 Buckland, p.75
 L-S, pl.113
 V & A, pl.47
Roger Fenton, c.1855
 Gernsheim-5, pl.138
Still Life, 1850s(?)
 L-S, pl.63
 Scharf-2, p.118

DIAMOND, Paul (American, 1942-)
Canine Experience, San Francisco,
1975

Coleman, pp.68-69
Dessert, San Francisco, 1974
 Coleman, p.68
Flat Top Photo, Father and Son,
 Brooklyn, 1973
 Wise, p.96
Half Lost, San Francisco, 1974
 Coleman, p.160
Hopi Bridgework, San Francisco,
1975
 Coleman, p.66
Princess, Rockaway, 1972
 Wise, p.97
Street Game, New York City, 1974
 Coleman, pp.66-67
This Softer than Harder, Los
 Angeles, 1976
 Coleman, pp.64-65
Tourist Placitas, 1971
 Wise, p.96
Victor's Faces, Nashville, 1971
 Coleman, pp.160-61
View of San Francisco, 1974
 Wise, p.97
View of the East River, 1972
 Wise, p.99
Williamsburg Bridge, 1974
 Wise, p.99
The Woman to My Right, Berkeley,
1974
 Wise, p.98
Woman's Hand, East Bay, 1974
 Wise, p.98

DIBBETS, Jan (Dutch, 1941-)
Painting Film Black Vase Hori-
 zontal, 1972
 Kahmen, pl.352
Panorama (Dutch Mountains), 1971
 Kahmen, pl.353 (col.)

DI BIASE, Michael (1925-)
Good Friday Service (Untitled),
 1962 or 1963
 Lyons-1, p.131
 T-L-3, pp.194-95

DICKEMAN, C. E. (American)
Cabinet photograph, c.1880
 Coleman, p.14

DICKINS, C. S. S. (British)
Gordon Castle, 1854, calotype
 negative
 Newhall-1, p.32

DICKINSON, Donald (American,
 1941-)
 Self Portrait at Buttermilk with
 Silver Sky, 1968, applied
 acrylic color and silver sen-
 sitizer on canvas
 Lyons-3, p.109

DIEUZAIDE, Jean See YAN

DILLE, Lutz
 Laughing Man, 1962
 T-L-5, p.26

DILLEY, Clyde (American, 1939-)
 Reflections of My Philosophy,
 1967
 Lyons-3, p.152

DINE, Jim (American, 1935-)
 Richard Hamilton, 1968
 Kahmen, pl.251

DISDERI, Andre Adolphe Eugene
 (French, 1819-c.1890)
 Carte-de-visite, c.1860
 Coe, p.33
 Carte-de-visite, c.1860
 Mathews, fig.59
 Employees of the firm of Dis-
 deri, c.1860
 Braive, pp.108-09
 Empress Charlotte of Mexico,
 1861, carte-de-visite
 Strasser, p.55
 Henri Monnier, c.1860
 Braive, p.91
 Horace Vernet, c.1860, carte-de-
 visite
 Pollack, p.163
 Ingres, c.1860, carte-de-visite
 Pollack, p.163
 Lord Granville, c.1860, carte-
 de-visite
 Strasser, p.57
 Martha Muravieva, 1864, carte-
 de-visite
 Pollack, p.158
 Scharf-2, p.157
 Merante, Coralli, Terraris and
 Louise Fiocre in the costumes
 of the ballet, Pierre de Medi-
 cis, prob.1876
 Scharf-2, p.142
 Napoleon III, c.1854, carte-de-
 visite

 Mathews, fig.55
 Napoleon III, c.1860
 Pollack, p.161
 Napoleon III and Empress Eugenie,
 1860s
 L-S, pl.110B
 Napoleon III, the Empress Eugen-
 ie and the Prince Imperial,
 1859-60
 Gernsheim-1, p.71
 Gernsheim-5, pl.179
 Prince and Princess de Metter-
 nich, c.1860, carte-de-visite
 Coke, p.54
 Scharf-2, p.146
 Princess Buonaparte-Gabriele,
 c.1862, uncut sheet of 8
 cartes-de-visite
 Gernsheim-1, p.70
 Gernsheim-4, fig.36
 Gernsheim-5, pl.181
 Uncut print of 8 cartes-de-
 visite, c.1860
 Newhall-1, p.53
 (attributed to)
 Execution of Maximilian, prob.
 1867, composite carte-de-
 visite
 Scharf-2, p.47
 (Disderi et Cie.)
 Carte-de-visite, c.1858
 Mathews, fig.60

DIVOLA, John (1949-)
 Vandalism, 1974
 Dennis, p.197

DIXON, Henry (British)
 The Office of the 'Daily News',
 Founded by Charles Dickens, in
 Fleet Street, Shortly Before
 Demolition, 1884
 Gernsheim-4, fig.93
 The Oxford Arms, Warwick Lane,
 1875, carbon print
 V & A, pl.29
 The Oxford Arms, Warwick Lane,
 1877, carbon print
 Gernsheim-5, pl.154
 (attributed to; also to A. & J.
 Boole)
 Lambeth Old House, Palace Yard,
 London, 1883
 ACGB, pl.34
 The Oxford Arms, Warwick Lane,
 London, 1875
 Mathews, fig.144

Pollack, p.509
Korean War, 1950
Pollack, pp.510-11
Korean War, 1950
Pollack, pp.512-13
Korean War, 1950
Pollack, p.514
Korean War, 1950
Pollack, pp.516-17
Korean War (Capt. Ike Fenton,
No Name Ridge, Korea), 1950
MOMA-1, p.155
Pollack, p.515
Marine in Korea, 1950
T-L-5, p.238
Marine in Korea, 1950
T-L-5, p.239
Marines in Vietnam, 1968
T-L-5, pp.228-29

DUNMORE & CRITCHERSON (American)
Man and Boy on Floating Ice,
Labrador, 1864
Greenhill, pl.60
Scharf-1, fig.5.7
Sailing Ships in Ice Fields,
Labrador, 1864
Greenhill, pl.59
(attributed to John Dunmore)
View of the Semitsialik Glacier
(Greenland), 1868
Naef, fig.130

DURIEU, Eugene
Male Nudes (from an album be-
longing to Delacroix), prob.
1853
Scharf-2, p.91
Models posed by Delacroix, 1854
Beaton, p.13
Nude man, c.1854
Coke, p.10
Nude man and woman, c.1854
Coke, p.10
Studies, 1854
Coke, p.8

DUTILLEUX, Eugene
Camille Corot at Arras, 1871
Gernsheim-4, fig.111

DUTTON, Allen A.
Always Be Leery of Lechery
Coleman, pp.152-53
A Fortuitous Tout Ensemble
Coleman, p.156

I Think That I Shall Never Wit
Coleman, p.158
Lievlum, 1968
Coleman, p.208
Perspicacity Requires a Head
Coleman, p.158
Plausible Humbuggery of the
Perspective
Coleman, p.155
The Protestant Revival of Meat
Coleman, p.157
The Specter of Tumid Titans
Coleman, p.154
Who Said Sculpture Was Dull?
Coleman, pp.158-59

DYE, David (British, 1945-)
The Kiss, 1975-76, photo diagram
Graz, p.55
Target Practice, 1975-76, six
circular photographs
Graz, p.54
(Photographs of David Dye)
David Dye, photographer unknown
Graz, p.56

DYVINIAK, William W.
Automobile Accident, 1945
T-L-6, p.40

EAKINS, Thomas (American, 1844-
1916)
Amelia C. Van Buren, c.1891,
platinum print
Jareckie, p.45
Boy Jumping, 1884-85
Gernsheim-5, pl.251
Boy Playing Pipes, c.1900
Coke, p.85
Double Jump, 1885
Kahmen, pl.52
Newhall-1, p.87
Frank Hamilton Cushing, 1895
Coke, p.44
Man Running, 1884-85
Gernsheim-5, pl.250
Man Walking, 1884, wet-plate
photograph
Pollack, p.222
Margaret Eakins, 1882, glass
positive
Pollack, p.221
Mary Macdowell, c.1886
L-S, pl.49

GLOEDEN, Count von
 Untitled
 Beaton, p.24

GLUCK, Barbara
 Bamiyan Afghanistan, 1973
 Hayes, col.pl.8
* Coconut Monk Disciple, Phoenix
 Island, Vietnam, 1973
 Hayes, pl.99
 Shoeshine Boy, Saigon, Vietnam,
 1973
 Hayes, pl.45
 Soldier, Marble Mountain, Viet-
 nam, 1973
 Hayes, pl.29

GODDARD, Paul Beck (American)
 The Eleventh Annual Exhibition of
 the Franklin Institute, Oct.
 1842, daguerreotype (1893 fac-
 similie)
 Taft, p.21

GODWIN, Fay (British, 1931-)
 Ridgeway, Barbury Castle Clump,
 1974
 Land, pl.43

GOHLKE, Frank (American, 1942-)
 Landscape, 1974
 Monsen, p.69
 Landscape, Minneapolis, 1973
 Topographics, p.26
 Landscape, St. Paul, 1974
 Topographics, p.27
 Landscape, Water Tower Under
 Construction, Wayzata, Minne-
 sota, 1974
 Topographics, p.25
 Untitled, 1972
 Light, p.14

GOLD, L. Fornasieri (American)
 Politician, New York City
 Hayes, pl.24
 Wedding in Brooklyn
 Hayes, pl.92

GOLDBERG, Beryl
 Weaver, Bonwire, Ghana
 Hayes, pl.20

GOLDIN, John & Co.
 The White House, Washington, 1865
 Taft, p.146

GOODHALL, Thomas F.
 Gunner Working Up to Fowl, 1885,
 platinotype
 Gernsheim-3, pl.63
 Setting the Bow Net, 1885, pla-
 tinotype
 Gernsheim-3, pl.62

GORA, Ray
 Ah! There's the ball and alas
 there also is the beer, Oct.3,
 1959 (Chicago Tribune)
 MOMA-4, p.22

GORDON, Elly (American, 1943-)
 Untitled, 1968, Kodalith print
 Lyons-3, p.128

GORO, Fritz
 Control of Life, 1958
 Pollack, p.433 (col.)
 Hologram, 1965
 Pollack, p.433 (col.)
 Lichens on Arctic Tundra in
 Midnight Sun, 1957
 Pollack, p.424 (col.)
 South American Railroad Worm,
 1947
 Pollack, p.432
 South Sea Island Circumcision
 Pollack, p.474
 Splitting of the Uranium Atom,
 1950
 Pollack, p.432 (col.)

GORREE, Fred
 Duane Michals, 1965
 Lyons-2, p.45

GOSSAGE, John R. (American,
 1946-)
 Alley Off S Street, Washington,
 D.C., 1974
 Baltimore, p.56
 Corn, Washington, D.C., 1974
 Baltimore, p.57
 4708 Reservoir Road, Washington,
 D.C., 1973
 Baltimore, p.55
 Kenilworth Aquatic Gardens,
 Washington, D.C., 1973
 Baltimore, p.54

GOWIN, Emmet (American, 1941-)
 Barry, Dwayne and Turkeys,
 Gainesville, Md., 1969

Camera, p.213 (col.)
Nude Dressing, 1952
 MOMA-5, p.110
Studio, Zurich
 Braive, p.339

GROOM AND COMPANY (British)
 The Impregnable, 1869
 Mathews, fig.100

GROOVER, Jan (American, 1943-)
 Untitled (2 images), 1974
 Wise, p.30

GROS, Baron Jean Baptiste Louis
 (French, 1793-1870)
 Athens, 1850, daguerreotype
 Braive, pp.58-59
 The Monument of Lysicrates,
 Athens, 1850, daguerreotype
 L-S, pl.3
 Street of the Observatory,
 Bogota, 1842
 Braive, p.206

GROSSBARD, Henry
 Untitled, 1970
 T-L-3, pp.156-57 (col.)

GROSSI, Emilio (American, 1924-)
 4 Series, In an Empty Place,
 No.4, 1964
 Sixties, p.18

GROSSMAN, Sid (American, 1915-
 1955)
 Coney Island, 1947-48
 T-L-2, pp.94-95
 San Gennaro Festival, 1949
 T-L-2, p.87

GRUNBAUM, Dorien (American)
 Chris and Toby and Fred
 Hayes, pl.67
 Fred with Chris and Toby
 Kalmus, p.95
 Holland
 Hayes, pl.102
 Paternity
 Hayes, pl.66

GRUNDY, William Morris (British,
 1806-1859)
 'The Country Stile,' 1859
 Gernsheim-1, p.93
 Gamekeepers by a Stile, c.1857

ACGB, pl.15
Huntsmen and their game (from
 Sunshine in the Country, 1861)
 Jones, p.52
Riverside View (from Sunshine
 in the Country, 1861)
 Jones, p.53

GRYLLS, Vaughan (British, 1943-)
 The Lenin Museum, 1976, 8 photo-
 graphs on 3-D construction
 Graz, p.65
 Red Square, 20 photographs on
 3-D construction
 Graz, p.64
 State Universal Shop (Gum),
 1976, 12 photographs on 3-D
 construction
 Graz, p.65
 (Photographs of Vaughan Grylls)
 Vaughan Grylls, by G. Daniells
 Graz, p.66

GRZIMEK, Bernhard
 Herd of Gnu Fleeing Across the
 Serengeti National Park
 Camera, p.125 (col.)

GUENIOT, Claudine (French, 1946-)
 Une Allee vers la Lumiere, 1975,
 sepia-toned bromide print
 SFMA, n.p.

GUIBERT, Maurice
 Henri de Toulouse-Lautrec (the
 first true close-up), c.1896
 Gernsheim-1, p.179
 Henri de Toulouse-Lautrec at
 Malrome, c.1896
 Gernsheim-1, p.178
 Gernsheim-5, pl.302
 Toulouse-Lautrec, c.1890,
 trick photograph
 Braive, p.262

GUICHARD, Louis
 The Anatomy Lesson, after Rem-
 brandt, c.1895
 Braive, p.285

GUNN, Andre
 Lion
 Camera, p.117

1966, color bichromate print
 Lyons-1, p.143
Road and Rainbow, 1971, gum bi-
 chromate print on fabric with
 stitching
 SFMA, n.p.
Untitled, 1972, gum bichromate
 with colored thread stitchery
 Light, p.31

HAIKO, Robert F. (American,
 1942-)
 Kemp's Television, 1967
 Lyons-3, p.15

HAJEK-HALKE, Heinz
 Colored Light Graph
 Camera, p.229 (col.)
 Experimental Self-Portrait
 Braive, p.316
 Light Patterns, 1960
 Gernsheim-4, fig.230
 Nude, 1959
 Gernsheim-4, fig.278 (col.)

HALAMEK, Zdenek (Czechoslovakian,
 1943-)
 Nostalgia, c.1967
 Lyons-3, p.132

HALASZ, Gyula See BRASSAI

HALBERSTADT, Milton (American,
 1919-)
 Still Life with Tomatoes, 1962
 T-L-4, p.36 (col.)
 Untitled, 1962
 Sixties, p.19

HALL, Douglas Kent (American,
 1938-)
 Calf Roping, Pendleton, Oregon,
 1972
 Doty-2, pp.246-47
 Mesquitte, Texas, 1973
 Doty-2, pp.246-47

HALL, T. Clifford See GEOLOGICAL
 SURVEY

HALLMAN, Gary (American, 1940-)
 East Minnehaha, 1971-72
 Baltimore, p.60
 Lake Harriet, 1971
 Baltimore, p.58
 Minnehaha Alley, 1971-72

Baltimore, p.59
Quadna Mountain, 1974
 Baltimore, p.61

HALSMAN, Philippe (Latvian-
 American, 1906-)
 Bobby Fischer, 1967
 T-L-5, p.107
 Dali and the Seven Nudes (Dali
 and the Skull), 1951
 Pollack, p.494
 T-L-1, p.226
 Dali Atomicus, 1948
 Beaton, p.227
 T-L-4, p.29
 Dr. Robert Oppenheimer, 1958
 Newhall-1, p.184
 Homage to Op Art, 1965
 Pollack, p.494
 Ivan M. Vinogradov, 1961
 Pollack, p.420 (col.)
 J. Robert Oppenheimer, 1958
 T-L-1, p.227
 Judge Learned Hand, 1957
 Pollack, p.421 (col.)
 Mai Zetterling, 1955
 T-L-5, p.106
 Photographer and Camera, 1965
 T-L-5, p.125
 Professor Albert Einstein, 1948
 Gernsheim-4, fig.213

HALUSKA, Andre
 Untitled Landscape, 1969
 T-L-3, p.158 (col.)

HAMAYA, Hiroshi (Japanese, 1915-)
 Autumn Trees, c.1960
 Gernsheim-4, fig.279 (col.)
 The Child of the Farmer's
 Family, Aomori, Japan, 1957
 MOMA-5, p.144
 Fukui, Japan, 1960
 Beaton, p.233
 Rime on Pine Forest. Mt. Zao,
 Japan, 1962
 Pollack, p.426 (col.)
 Work in a Field of Mud, Toyama,
 Japan, 1955
 Camera, p.63
 MOMA-5, p.57

HAMILTON, Jeanne
 Moondog
 Hayes, pl.2

HAMILTON, Richard (British,
 1922-)
 Self-Portrait, 3.1.1972
 Kahmen, pl.250
 (Photographs of R. Hamilton--
 See Subject and Title Index)

HAMILTON, Virginia (American)
 Mr. Bobby Brooks
 Hayes, pl.96

HAMM, Clarence (American, 1903-)
 Cavemen Initiate Dewey, 1948
 MOMA-5, p.114

HAMMACHER, Arno (Dutch, 1927-)
 Detail of Iron Construction by
 Naum Gabo in Rotterdam, 1957
 Gernsheim-1, p.204
 Reeds in the Camargue, 1963
 Gernsheim-4, fig.282 (col.)
 Reflections in Amsterdam, 1951
 Gernsheim-1, p.203
 Torn Paper on Wood (designed by
 Walter Herdeg as cover of
 'Graphis Annual 61/62)
 Gernsheim-4, fig.175 (col.)

HAMMARSKIOLD, Caroline (Swedish,
 1930-)
 Fishnet Reflection, 1950
 Gernsheim-1, p.203
 Gernsheim-4, fig.232

HAMMARSKIOLD, Hans (Swedish,
 1925-)
 Bark of a Tree, 1952
 Gernsheim-1, p.199
 Gernsheim-4, fig.228
 Cross-Section Through a Tree,
 1951
 Gernsheim-1, p.201
 Gernsheim-4, fig.224

HAMMERSMITH, Lilian
 Untitled
 Beaton, p.27

HANDY, Levin C.
 M.B. Brady in middle age, 1875
 Taft, p.227
 (attributed to)
 Gardner's Gallery in Washington,
 1865
 Taft, p.230

HANFSTAENGL, Franz (German, 1804-
 1877)
 Frau Schwanthaler, widow of the
 sculptor F.X. Schwanthaler,
 c.1855, calotype
 Gernsheim-5, pl.87
 (attributed to)
 Corot, c.1860
 Braive, p.123

HANSCOM, Adelaide (American, 1876-
 1932)
 Untitled, 1905
 SFMA, n.p.

HARBUTT, Charles (American,
 1935-)
 Blind Child Grasping for Light,
 1961
 Doty-2, p.231
 Lyons-1, p.105
 Newhall-2, n.p.
 Bride in Cellar, 1966
 Doty-2, p.230
 Torso, 1972
 Doty-2, p.231
 Untitled, 1965
 Sixties, p.19

HARDY, Arnold (1923-)
 Hotel Winecoff Fire, Atlanta,
 Georgia, 1946
 Lyons-1, p.41

HARDY, Bert (British, 1913-)
 Beggar Children in Barcelona,
 1950
 Gernsheim-1, p.222
 The Colour Problem in Liverpool,
 1949
 Gernsheim-4, fig.271
 Inchon Landing, Korea, 1951
 ACGB, pl.77
 'Le Raconteur,' 1948
 Gernsheim-4, fig.264
 Scene in a Gorbals Pub, 31 Jan.
 1948
 ACGB, pl.78
 South Korean Political Prisoners
 at Pusan Awaiting Transport to
 a Concentration Camp and Exe-
 cution, 1950
 Gernsheim-1, p.221

HARE, Chauncey (American, 1934-)
 Home in a Basement, Berkeley,

1968
Lyons-3, p.73

HARE, David (American, 1917-)
Untitled "Improved photograph",
c.1942
Coke, p.241

HARISSIADIS, Dimitrios
Greek Frieze, 1955
Pollack, p.485

HARRINGTON, Diane
Untitled
Hayes, pl.46

HARRIS, George W.
(in collaboration with M. Ewing)
Calvin Coolidge
T-L-4, p.23
Dwight D. Eisenhower
T-L-4, p.23
Franklin D. Roosevelt
T-L-4, p.23
Herbert Hoover
T-L-4, p.23
John F. Kennedy
T-L-4, p.23
Theodore Roosevelt
T-L-4, p.22
Warren G. Harding
T-L-4, p.22
William Howard Taft
T-L-4, p.22
Woodrow Wilson
T-L-4, p.22

HARRIS, John Benton
The Tantrum, 1966
T-L-5, p.25

HARRIS, Kay
Apple, c.1960
Coke, p.292

HARRIS-McLEOD, Pamela (American,
1942-)
Mountain Family, Decoy, Kentucky,
1966
Lyons-3, p.19

HARRISON, Gabriel (American, 1817
or 1818-1902)
Girl Adoring a Bust of Washing-
ton, c.1853, daguerreotype
Rudisill, pl.149

The Infant Saviour Bearing the
Cross (posed by George Wash-
ington Harrison), 1853, da-
guerreotype
Rudisill, pl.43
Past, Present, and Future, 1851,
daguerreotype
Rudisill, pl.42
Stone Tower at Newport, R.I.,
1850, daguerreotype
Rudisill, pl.26
(attributed to)
Walt Whitman, c.1855, daguerre-
otype
Rinhart, p.19

HARRISON, J. T. (American)
"The Young Bachelor's Sunday
Morning," 1857
Rudisill, pl.94

HART, Alfred A. (American, 1816-?)
Alcove in Palidades, Ten Mile
Canon, No.399, c.1868
Naef, fig.60
Central Pacific Railroad, Forest
View, near Dutch Flat. No.65
Naef, fig.61
Excursion at Cape Horn, Three
Miles from Colfax, 1865
Taft, p.295
Flume and Railroad at Gold Run,
1865 or 1866
Taft, p.295
Meeting of the Rails, Promontory
Point, Utah, 1869
Newhall-1, p.75

HARTMANN, Erich (American, 1922-)
Ruth and Cassandra, 1971
Doty-2, p.236

HARTSHORN, S. W. (active in Provi-
dence, R.I. 1848-1850)
(attributed to)
Edgar Allen Poe, 1848, daguerre-
otype
Coke, p.48
Pollack, p.80

HASS, Ernst
Returning Prisoners of War,
Vienna, c.1948
Braive, p.331

Manhattan from Brooklyn Bridge,
1919
Gernsheim-1, p.181
Gernsheim-2, p.117
Gernsheim-4, fig.197
Policeman in Siena, 1936
ACGB, pl.67
Prince Regent of Bavaria, 1909,
platinotype
Mathews, fig.251
Ship in Drydock, 1928
Gernsheim-1, p.180

HOREAU, Hector (French)
Luxor (from Panorama of Egypt
and Nubia, Paris, 1841), aqua-
tint from daguerreotype
Aperture, no.123
Thebes: Hypostyle Hall, Karnac
(from Panorama of Egypt and
Nubia, Paris, 1841), aquatint
from daguerreotype
Aperture, no.122

HORETZKY, Charles (Canadian)
At the Elbow of the North Sas-
katchewan River, September
1871
Greenhill, pl.48

HORNING, Christine (American)
Untitled 75 (portrait of my
father)
Kalmus, p.26

HORST, Horst P. (German-American,
1906-)
Coco Chanel, 1936 or 1937
Dennis, p.128
T-L-4, p.124
Ensemble by Hattie Carnegie,
1937
T-L-4, p.125
Raymond Massey as Abraham
Lincoln
Beaton, p.190

HOSKING, Eric (British, 1909-)
Barn Owl with Vole
Beaton, p.185

HOSOE, Eikoh (Japanese, 1935-)
(From) "Killed by Roses" ("Or-
deal by Roses"), 1963
Coleman, p.106
Lyons-1, p.128

(From) "Killed by Roses", 1963
Coleman, pp.102-03
(From) "Killed by Roses", 1963
Coleman, p.104
(From) "Killed by Roses", 1963
Coleman, p.105
(From) "Killed by Roses", 1963
MOMA-6, pp.80-81
(From) Man and Woman, 1961
Coleman, pp.106-07
MOMA-6, pp.82-83

HOUGHTALING, Susan (American)
Untitled
Kalmus, p.93

HOUSEWORTH, Thomas
The Magic Tower-on the Union
Point Trail, c.1867
Naef, fig.79
(in collaboration with Lawrence)
California Art Union, Montgomery
Street, from Eureka Theater,
No.47, c.1864
Naef, fig.41
Camp of Mormons at Lake Tahoe,
c.1865
Naef, fig.57
Exterior of Lawrence and House-
worth's Store, San Francisco
No.169, 1864
Naef, fig.42
Montgomery St., San Francisco,
from Market St., c.1864
Naef, fig.95

HOWARD, Tim
Electrocution of convicted mur-
derer Ruth Snyder, Jan.13, 1928
Coleman, p.29

HOWLETT, Robert (British, 1830-
1858)
Grandstand and people on Derby
Day, 1856
Coke, p.78
Isambard Kingdom Brunel, 1857
Gernsheim-1, p.61
Gernsheim-2, p.93
Gernsheim-4, fig.104
Gernsheim-5, pl.134
L-S, pl.60
Mathews, fig.41
Newhall-1, p.72

HUGO, Charles Victor (French,
 1826-1871)
 Madame Victor Hugo's Arm, 1853-
 55
 Mathews, fig.33
 Victor Hugo, 1853-55
 Mathews, fig.32
 Victor Hugo, 1858-60
 Braive, p.131
 Victor Hugo's Cat, 1853-55
 Mathews, fig.34

HUJAR, Peter
 Untitled
 Coleman, pp.60-61
 Untitled
 Coleman, p.61
 Untitled
 Coleman, p.62
 Untitled
 Coleman, p.63

HUMPHREY, Henry
 A Day in the Life of Maud
 Humphrey (photo series)
 T-L-6, pp.142-45

HUMPHREY, Samuel Dwight (American,
 active 1849-1859)
 Multiple exposure of the moon,
 Sept.1, 1849, daguerreotype
 Rudisill, pl.21

HURLEY, Frank
 Ron looks like he's sorry,
 April 24, 1967 (Daily News)
 MOMA-4, p.74

HUTTON, J. D.
 (attributed to)
 Falls on the Yellowstone River,
 1869
 Naef, fig.30

HUTTON, Kurt (Kurt Hubschmann)
 (German-British, 1893-1960)
 At the Fair (Scenic Railway at
 the Fair), 1938
 Gernsheim-1, p.217
 Gernsheim-2, p.125
 Gernsheim-4, fig.268

HYDE, Philip (1921-)
 Sand Dunes on the Colorado River,
 Grand Canyon, 1956
 Lyons-1, p.82

HYDE, Scott (1926-)
 Caddie, 1971
 Kansas, fig.52
 Mayflower, 1966, color dichromate
 process
 Lyons-1, p.87

ICHIMURA, Tetsuya (Japanese,
 1930-)
 Court Ladies, Kyoto Palace, Kyo-
 to, 1968
 MOMA-6, p.63
 Kamikaze, Memorial of the War
 Dead in Yasukuni Shrine, Tokyo,
 1964
 MOMA-6, p.61
 Kimono, Shinjuku, Tokyo, 1964
 MOMA-6, p.60
 Meiji-maru, Etchu-jima, Tokyo,
 1967
 MOMA-6, p.62
 Nijubashi, Imperial Palace,
 Tokyo, 1965
 MOMA-6, p.58
 Old Man, Kenroku Park, Kanazawa,
 1966
 MOMA-6, p.59

IKKO (Ikko Narahara) (Japanese,
 1931-)
 Fossils at Pompeii, Italy (from
 Where Time Has Stopped, 1967),
 1964
 MOMA-6, p.79
 Roller-Skating Rink, Colorado,
 1972
 MOMA-6, p.75
 Room No.9, Women's Prison, Waka-
 yama (from Man and His Land,
 1971), 1958
 MOMA-6, p.74
 Side of Pool, Lake Powell, Utah,
 1971
 MOMA-6, p.77
 Two Garbage Cans, Indian Village,
 New Mexico, 1972
 MOMA-6, p.78
 Two Ladies with Identical Jackie
 Kennedy Masks, New York, 1970
 MOMA-6, p.76

April 1936
 Vision, p.78
Newsboys, Jackson, Ohio, April
 1936
 Vision, p.82
One-legged Man, 1936
 Hurley, p.79
Prospective client whose proper-
 ty has been optioned by the
 government, Brown County, Indi-
 ana, Oct.1935
 Vision, p.24
Rehabilitation client's wife,
 Jackson County, Ohio, April
 1936
 Vision, p.79
Sunday dinner, Jackson, Ohio,
 April 1936
 Vision, p.81
Typical interior of cabin, Gar-
 rett County, Maryland, Sept.
 1935
 Vision, p.17
Young fellows in front of pool
 hall, Jackson, Ohio, April
 1936
 Vision, p.80
Younger part of a family of ten
 to be resettled on Ross-Hock-
 ing Land Project, Chillicothe,
 Ohio, April 1936
 Vision, p.83
(Photographs of Theodor Jung)
Theo Jung, photographer unknown
 Vision, p.300
Theo Jung, 1936, by H. Geiger
 Vision, p.26

JUNOD
 Prince Frederick-Charles of
 Prussia and His Staff, c.1861
 Braive, p.139

KAGAN, Gary
 Untitled (Mrs. Laura McCrary
 hit by car), n.d. (Daily News)
 MOMA-4, p.42

KAGE, Manfred
 Crystal Paintings
 Camera, pp.237-40 (col.)
 Orlon magnified 20x, enlarged
 to 45x, 1969
 T-L-4, p.214 (col.)

Water Drop on a Curtain, 1970
 T-L-4, p.218 (col.)

KAHN, Steve (American, 1943-)
 Untitled, n.d.
 Light, p.19

KALISHER, Simpson (American,
 1926-)
 Boy Pushing a Car, 1960
 Doty-2, p.228
 Bus Group, New York, 1961
 UNC, pl.15
 Men on Wall Street, New York,
 1961
 UNC, pl.52
 Untitled
 Sixties, p.23
 Untitled, 1961
 Lyons-1, p.93

KANE, Art
 Girl in Blue Stockings, 1963
 T-L-4, p.138 (col.)
 New York Woman, 1970
 T-L-4, p.133 (col.)

KANTOR, Tim (1932-)
 The People on the Beach,
 Florida, 1957
 Lyons-1, p.68
 Senator Edmund S. Muskie
 T-L-6, p.108 (col.)
 Senator Edmund S. Muskie
 T-L-6, p.109 (col.)

KAR, Ida (Russian, 1908-)
 Fish, 1963
 Gernsheim-4, fig.283 (col.)
 Marc Chagall, 1954
 Gernsheim-1, p.213
 William Scott, 1961
 Gernsheim-4, fig.209

KARLSSON, Stig T. (Swedish)
 Seascape with Driftwood
 Camera, pp.98-99

KARSH, Yosuf (Turkish-Canadian,
 1908-)
 Albert Einstein, 1948
 Pollack, pp.586-87
 Ernest Hemingway, 1957 or 1958
 Beaton, p.178
 Pollack, p.583
 T-L-5, p.116

burros to get cash for his
farm, Pie Town, New Mexico,
1940
Hurley, p.105
Kitchen of Tenant Purchase Cli-
ent, Hidalgo, Texas, 1939
Kahmen, pl.215
MOMA-5, p.33
Lafayette, Louisiana, 1938
Stryker, pl.169
Lon Allen and his son playing
their fiddles to the tune of
"The Arkansas Traveler", near
Iron River, Michigan, May
1937
Vision, p.129
Lumberjack in saloon; Craigville,
Minnesota, 1937
Stryker, pl.67
Lunchtime at an all-day community
sing; Pie Town, New Mexico,
1940
Stryker, pl.172
Mass meeting called to discuss
ways and means for raising
county funds to continue WPA
road work, San Augustine,
Texas, April 1939
Vision, p.186
Medicine sign, Pine Bluffs,
Arkansas, Oct.1938
Vision, p.159
Mexicans, San Antonio, Texas,
March 1939
Vision, p.185
Migrant child returning from
fields; Prague, Oklahoma, 1939
Stryker, pl.76
Morganza, Louisiana, 1938
Stryker, pl.98
Mother and Child, Oklahoma, 1939
T-L-2, p.82
Mound Bayou, Louisiana, 1939
Stryker, pl.14
Negro child playing phonograph
in cabin home, Transylvania
Project, Louisiana, Jan.1939
Vision, p.172
Negro drinks at "colored" water
cooler in streetcar terminal,
Oklahoma City, Oklahoma, July
1939
Vision, p.195
New Iberia, Louisiana, 1938
Stryker, pl.VIII
New Madrid County, Missouri,

1938
Stryker, pl.17
North Dakota, 1937
Stryker, pl.97
Oldtimers near courthouse, San
Augustine, Texas, 1939
Hurley, p.117
Once a year the women in the
Spanish American families
replaster the adobe houses,
Chamisal, New Mexico, July
1940
Vision, p.238
Orange County, Vermont, 1939
Stryker, pl.110
An organ deposited by the flood
on a farm near Mt. Vernon,
Indiana, Feb.1937
Vision, p.125
Picking Cotton, Lake Dick Crop
Association, 1938
Thornton, pp.152-53
Pie Town, New Mexico, 1940
Stryker, pl.18
Pie Town, New Mexico, 1940
Hurley, p.119
Quilt Made by Mrs. B.S., Pie
Town, New Mexico, 1940
MOMA-5, p.93
A Radiator Cap; Laurel, Missis-
sippi, 1939
Stryker, pl.VII
Vision, p.136
Rancher at county fair; Gonzales,
Texas, 1939
Maddow, p.315
Stryker, pl.55
Refugees in a schoolhouse;
Sikeston, Missouri
Maddow, p.314
Stryker, pl.39
Roadside camp of migrant workers;
Lincoln, Oklahoma, 1939
Stryker, pl.130
San Augustine, Texas, 1939
Hurley, p.105
San Augustine, Texas, 1939
Hurley, p.117
San Marcos, Texas, 1940
Stryker, pl.7
Saturday night in a saloon,
Craigsville, Minnesota, Sept.
1937
Vision, p.134
Scene in an agricultural workers'
shack town; Oklahoma, 1939

1972
Wise, p.182 (col.)
S.W. 8th St., Miami, Florida,
1970
Wise, p.177
Sheffield St., Chicago, 1973
Wise, p.180
St. Lazarus, Chicago, 1971
Wise, p.181

LORELLE, Lucien
The Child and the Lights
Braive, p.362

LOTTI, Giorgio (Italian, 1937-)
Mare, 1970
Land, pl.34

LOUNEMA, Risto (Finnish, 1939-)
December Sun (10 December 1961
12 a.m.)
Land, pl.45

LOUVOIS (active in Brussels)
Baby, c.1900
Braive, p.304

LOVE, J. W. (American)
Our Sail Boat on the Muskoka
River C.W., c.1865, stereo-
graph
Greenhill, pl.37

LOWRIE, J. F. (British)
Ferrotype, c.1890
Mathews, fig.170

LUBOSHEZ, Nahum Ellan (Russian,
1869-1925)
Famine in Russia, c.1910
Gernsheim-1, p.113
Gernsheim-4, fig.130
Gernsheim-5, pl.262

LUKS, Wilhelm (Austrian)
The Duchess of Hamilton, c.1882
L-S, pl.104

LUMIERE, Louis (French, 1864-1948)
His Father Antoine, c.1905,
autochrome
Scharf-1, fig.10.1 (col.)
Lyons in the Snow, c.1908, auto-
chrome
Scharf-1, fig.10.2 (col.)
Young Lady with an Umbrella, c.

1907
Scharf-1, fig.10.3 (col.)

LUSKACOVA, Marketa (Czechoslova-
kian, 1944-)
Untitled, n.d.
SFMA, n.p.

LUSWERGH (active in Rome)
Peasants of the Roman country-
side in local costume
Jones, p.58

LYNES, George Platt (American,
1907-1955)
Diogenes & Alexander, c.1945
Dennis, p.130
Henri Cartier-Bresson, 1935
Maddow, p.383
Mina Loy, 1931
Lyons-1, p.31
Nude
Camera, p.170
Untitled
Beaton, p.230
W.H. Auden, 1939
Maddow, p.382

LYNNE, Jill (American)
Man with Pinball Machine
Hayes, pl.100

LYON, Danny (American, 1942-)
Cotton Pickers, c.1970
Kahmen, pl.166
Crossing the Ohio, Louisville,
c.1966
Doty-2, p.236
Funeral, Renegades, Detroit
(from "The Bike Riders"),
1966
Beaton, p.246
Funeral, Renegades, Detroit
(from "The Bike Riders"),
1966
Lyons-2, p.40
Hyde Park, Chicago, 1965
Lyons-2, p.36
Illiana Speedway, Indiana (from
"The Bike Riders"), 1965
Lyons-1, p.141
Lyons-2, p.43
Jack (from "The Bike Riders"),
1965
Lyons-2, p.41
Main corridor (penitentiary in-

MAYHEW, W. C.
 Samuel Woodhouse, June–July
 1850, daguerreotype
 Naef, fig. 30
 Sitgreaves Expedition, July 26,
 1850, daguerreotype
 Naef, fig. 31

MAYNARD, Richard (British-Canadi-
 an, 1832–1907)
 Freight Wagons at Boston Bar in
 the Fraser Canyon, prob. early
 1880s
 Greenhill, pl. 100

MAYNE, Roger (1929–)
 Sheep Shearing, Snowdonia, 1962
 Lyons-1, p. 104
 Tears, 1956
 Pollack, p. 464
 Tension, 1956
 Pollack, p. 465

MEADE BROTHERS (New York)
 L.J.M. Daguerre, 1848, da-
 guerreotype
 Taft, p. 2
 Reverend Beekman, c. 1850,
 daguerreotype
 Rudisill, pl. 112

MEATYARD, Christopher (American,
 1955–)
 Untitled, 1973, bromide print
 using solarization
 Light, p. 29

MEATYARD, Ralph Eugene (American,
 1925–1972)
 Caroling, Caroling, 1963 or
 1964
 Monsen, p. 39
 Sixties, p. 28
 Lucybelle Crater and Jonathan
 Greene, 1971
 Coleman, p. 112
 Lucybelle Crater and Sarah
 O'Callaghan, 1971
 Coleman, p. 112
 Madonna, 1969
 T-L-3, p. 219
 Untitled, n.d.
 Target, p. 52
 Untitled, c. 1962
 Coleman, p. 111
 Untitled, c. 1962

 Coleman, p. 115
 Untitled (#3 from "Romance (N)
 from Ambrose Bierce"), 1962
 Coleman, p. 110
 Lyons-1, p. 89
 Untitled, 1963
 Beaton, p. 244
 Untitled, c. 1964
 Coleman, p. 113
 Untitled, c. 1965
 Doty-2, p. 222
 Untitled, c. 1965
 Doty-2, p. 223
 Untitled, 1970
 Coleman, p. 114
 Untitled (Sound), 1970
 T-L-3, p. 206

MEDINA, Luis (Cuban-American,
 1943–) See LOPEZ, Jose and
 MEDINA, Luis

MEHEVIN, L. See LANGLOIS, Jean
 Charles

MEINERTH, Charles
 Marie, May 16, 1861
 Taft, p. 206

MELANDER, Silas and Lewis
 (Swedish-American)
 Chicago, 1876, stereoscopic
 card illumination
 Maddow, p. 85

MELANDRI (French)
 Emile Zola, c. 1870, carte-de-
 visite
 Mathews, fig. 56
 Sarah Bernhardt in "Ruy Blas"
 (from The Theatre, No. 11,
 new series), woodburytype
 Maddow, p. 140
 Sarah Bernhardt with Her Self-
 Portrait Bust, c. 1876
 Gernsheim-1, p. 65
 Gernsheim-4, fig. 106
 Maddow, p. 141

MENSCHENFREUND, Joan (American)
 Father and Daughter, Oregon
 Hayes, pl. 70

MERLIN, Henry Beaufoy (Australian,
 1830–1873)
 A Hill End home, Australia,

1872
 Newhall-1, p.80

MERTIN, Roger (American, 1942-)
 (From the series) "Plastic
 Love-Dream, 1968
 Lyons-3, p.115
 Rochester, N.Y., c.1965
 Monsen, p.146
 Untitled, Rochester, N.Y., 1966
 Lyons-1, p.119
 Untitled, Toronto, 1973
 Light, p.8

MESARDS, Ronald (American, 1942-)
 Dog and Ball, 1969
 T-L-3, p.210
 Vesta, 1968
 Lyons-3, p.93

MESSIER
 Carte-de-visite of Priest,
 c.1890
 Dennis, p.24

METZ, Gary (American, 1941-)
 (From the portfolio) "Song of
 the Shirt," 1967, color photo-
 offset lithograph, in colla-
 boration with John Moore
 Lyons-3, p.112

METZKER, Ray K. (American,
 1931-)
 Juniper Street, 1966-67
 T-L-3, p.170
 Man in Boat, 1961
 Lyons-1, p.120
 Untitled
 Sixties, p.29
 Untitled (Wall and Sky, Palm
 Tree)
 Wise, p.68
 Untitled, 1964
 Lyons-4, p.34
 Untitled, 1964
 Lyons-4, p.39
 Untitled, 1965
 Lyons-4, p.35
 Untitled, 1965
 Lyons-4, p.36
 Untitled, 1965
 Lyons-4, p.40
 Untitled, 1965
 Lyons-4, p.42
 Untitled, 1966

Lyons-4, p.37
 Untitled, 1966
 Lyons-4, p.38 (det.)
 Untitled, 1966
 Lyons-4, p.41
 Untitled, 1966
 Lyons-4, p.43
 Untitled, c.1969
 MOMA-1, p.201
 Untitled, 1969
 T-L-3, p.166
 Untitled (Landscape with Shadow),
 1971
 Wise, p.69
 Untitled (3 Shadowed Figures,
 Hose, and Wall), 1971
 Wise, p.70
 Untitled (Electric Meter and
 Stove), 1972
 Wise, p.71
 Untitled (House, Fence, and
 Black Pole), 1972
 Wise, p.70
 Untitled (Parking for Globe-
 trotters), 1972
 Wise, p.66
 Untitled (Photographer's Shadow
 and White Signs), 1972
 Wise, p.69
 Untitled (Stop Sign), 1972
 Wise, p.67
 Untitled, 1973
 Target, p.20

MEYER, Klaus
 Face, 1959
 Braive, p.318

MEYER, Pedro (Mexican, 1935-)
 Downfall of Symbols, 1974
 Wise, p.170
 Musician, 1974
 Wise, p.167
 El Papalero, 1974
 Wise, p.166
 Reflections Upon Reflections,
 1972
 Wise, p.168
 Sofia, 1974
 Wise, p.169
 Untitled, 1974
 Wise, p.170
 The Window of San Cristobal,
 1974
 Wise, p.171

NADAR, Paul (Paul Tournachon)
(French)
George Eastman, Paris, 1890
Pollack, p.236

NAGAO, Yasushi
Inejiro Asanuma and Assassin,
1960
T-L-6, p.31

NAITOH, Masatoshi (Japanese,
1938-)
Hags, 1968-70, series of 8
photographs
MOMA-6, pp.56-57

NAKAHARA, Tokutaro (Japanese)
Swans, 1968
T-L-5, p.177

NARAHARA, Ikko See IKKO

NASH, Paul
Monster Field, Study No.1,
c.1943
Gernsheim-1, p.181

THE NATAL STEREO AND PHOTOGRAPHIC
COMPANY (Pietermaritzburg, South
Africa)
The Pioneer, 1880s
L-S, pl.83

NATALI, Enrico (American, 1933-)
Billiard Players, Watertown,
New York, 1965
Sixties, p.30
Businessman at a Press Party,
Detroit, 1969
Maddow, p.370
New Orleans, 1962-63
Lyons-1, p.126

NAUMAN, Bruce (American, 1941-)
Burning Small Fires, 1968
Kahmen, pl.332
Cold Coffee Thrown Away, 1966
Kahmen, pl.311 (col.)
(From) First Hologram Series
(Making Faces), 1968
Kahmen, pl.318
Light Trap for Henry Moore, No.1,
1967
Kahmen, pl.312
Light Trap for Henry Moore, No.2,
1967

Kahmen, pl.313
(From) Second Hologram Series,
1969
Kahmen, pl.316
William T. Wyley or Ray Johnson
Trap, 1967
Kahmen, pl.310

NAY
Tourists in a Salt-Mine, Berch-
tesgarden, c.1885
Braive, p.259

NAYA, C. (Italian)
Ponte dei Sospiri, Venezia
Jones, p.60
Venezia Piazza di S. Marco
Jones, p.58

NAYSMITH, Terence
Landscape, 1969
T-L-3, p.58 (col.)

NEEDHAM, Ted
In this dramatic photo, horror
is clearly etched on the faces
of these two boys as policeman
lifts the sheet which covers
the body of their slain play-
mate, July 15, 1947 (UPI)
MOMA-4, p.49

NEFF, Peter (American)
Tom, the boy at Yellow Springs,
Jan.1855, tintype, in colla-
boration with Hamilton Smith
Taft, p.164

NEGRE, Charles (French, 1820-1879
or 1880)
Abbey of Montmajour (from Le
Midi de France), 1852, positive
print from wax paper negative
Aperture, no.25
L'Acquaiuolo, 1852, positive
print from wax paper negative
Aperture, no.107
Chartres Cathedral, statue-
columns, 1855, photogravure
Aperture, no.33
Chimney Sweeps, Quai Bourbon,
1852
Buckland, p.82
Gothic Sculpture, St.Gilles du
Gard Abbey, 1852, calotype
Gernsheim-5, pl.92

PHIZ
 Awful Discovery, 1860, hand-
 colored stereo-card
 Jones, p.95 (col.)
 The Fast Day, hand-colored
 stereo-card
 Jones, p.94 (col.)
 Hamlet, Act III, Scene 5.
 'Confess yourself to heaven,'
 hand-colored stereo-card
 Jones, p.92 (col.)
 Hamlet, Prince of Denmark, Act
 V, Scene 1. 'Alas, Poor
 Yorick!', 1856, hand-colored
 stereo-card
 Jones, p.93 (col.)
 Hamlet's Father's Ghost, hand-
 colored stereo-card
 Jones, p.92

PIALLAT (French)
 Warehouse of Edmond Ganneron,
 Specialite de materiel agri-
 cole, n.d., photo-lithograph
 Aperture, no.226

PICHERIE, Roger
 Pope Paul VI blessing the waters
 of Lake Tiberias, Israel, 1964
 Braive, pp.336-37

PICKENS, Marjorie (American)
 Teenager in water fountain spray
 Kalmus, p.82

PICKERSGILL, F. R.
 Sunshine and Shade, c.1859
 Beaton, p.12

PIERSON See MAYER AND PIERSON

PIERSON, Louis (French, 1818-1913)
 Napoleon III, 1851
 Strasser, p.51

PILBROW, David (American, 1940-)
 Portrait Feet, 1968
 Lyons-3, p.100

PITCAIRN-KNOWLES, Andrew (British)
 Sea Food, c.1900
 ACFB, pl.59

PLACHY, Sylvia (American)
 Kite flying, Long Island
 Kalmus, pp.78-79

PLASSON, Gardar (Icelandic,
 1922-)
 Lava Flows from Surtsey, Ice-
 land, 1964
 Land, pl.3

PLATNIK, Sam
 The Moment's Not For Him (Cadet
 Eugene Landy), Aug.6, 1955
 (Daily News)
 MOMA-4, p.23

PLEWINSKI, Wojciech
 The Interpenetrations, 1968
 T-L-5, p.154

PLUMBE, John, Jr. (Welsh-American,
 1809-1857)
 Miss Anna Louisa Chesebrough,
 age three, 1846, daguerreotype
 Taft, p.47
 Old Patent Office, Washington,
 D.C., c.1846, daguerreotype
 Newhall-4, pl.5
 The United States Capitol,
 1846, "plumbeotype"
 Taft, p.51
 Washington Irving, 1852, da-
 guerreotype
 Coke, p.41
 Newhall-4, pl.61
 Young Man from Boston (probably
 Henry D. Thoreau), c.1841,
 daguerreotype
 Rinhart, p.30
 (attributed to)
 The Capitol, Washington, from
 the East, 1846, daguerreotype
 Coe, p.83

POHLMAN STUDIOS
 Snowmobile, 1970
 T-L-4, p.69 (col.)

POITIER, Jacqueline (British-
 American)
 Dancer and baby
 Kalmus, p.89

POLAK, Richard (American, 1870-
 1957)
 The Artist and His Model (The
 Painter and His Model), 1914
 or 1915
 Beaton, p.119
 Scharf-2, p.186

The Little Golfplayer, 1913
 Mathews, fig.252
Photograph in the Style of
 Pieter de Hoogh, 1914
 Gernsheim-1, p.132
 Gernsheim-4, fig.169
 Gernsheim-5, pl.293

POLIN, Nancy (American)
Untitled
 Kalmus, p.84

POLLACK, Sir George Frederick
 (British?, 1930-)
Vitrograph, 1964
 Gernsheim-4, fig.231 (col.)

POLLOCK, Henry (British, 1826-
1889)
(attributed to)
A Viaduct on the South Eastern
 Railway, 1850s
 L-S, pl.58

POLYBLANK See MAULL AND POLY-
BLANK

PONTI, Carlo (Italian)
Courtyard of the Doge's Palace,
 Venice, c.1860
 Gernsheim-2, p.97
 Gernsheim-5, pl.163
Great Bronze Horses, Venice,
 c.1860
 Gernsheim-5, pl.161
 T-L-1, p.52
Piazza San Marco, Venice, c.
 1862
 Gernsheim-1, p.55
 Gernshcim-4, fig.91
 Gernsheim-5, pl.164
Venice, c.1860
 Mathews, fig.96

PONTING, Herbert G. (British,
1871-1935)
Hut, Iceberg, and Mountain,
 1910-12
 ACGB, pl.55
Men in a Hut, 1910-12
 ACGB, pl.57
The 'Terra Nova' in the Ant-
 arctic, 1912
 Gernsheim-4, fig.82
 Gernsheim-5, pl.268

PORETT, Thomas (American, 1942-)
Untitled, 1967
 Lyons-3, p.94
Untitled, 1969
 T-L-3, p.152

PORTER, Eliot Furness (American,
 1901-)
Abandoned Farm, Iceland, 1972
 Doty-2, p.202 (col.)
Arctic Tern
 Beaton, p.192
Birch and Frozen Lake, Adiron-
 dacks, 1965
 Sixties, p.32
Blue-Throated Hummingbird
 Camera, p.131 (col.)
Highest Waterfall, Davis Gulch,
 Escalante River, Lake Powell,
 Utah, 1965
 Doty-2, p.203 (col.)
Lichens on Round Stones, South
 Coast, Iceland, 1972
 Doty-2, p.202 (col.)
Maple Sapling
 Newhall-2, n.p.
Rainbow Bridge, Glen Canyon,
 Utah, 1961, color print
 Coke, p.295
White-Winged Turtle-Dove
 Camera, p.134 (col.)

PORTER, Fairfield (American,
1907-1975)
Walking in the garden, 1963
 Coke, p.218

PORTER, William Southgate (1822-
1889)
Panorama of Eight Daguerreo-
 types of the Cincinnati
 Waterfront, 1849, in colla-
 boration with C.Fontayne)
 Newhall-1, p.29 (1 view)
 Scharf-1, pp.30-31 (8 views)

POST-WOLCOTT, Marion (American,
 1910-)
Baptismal service; Morehead,
 Kentucky, 1940
 Doherty, pl.57
 Stryker, pl.145
The bar on Saturday night in
 Birney, Montana, Aug.1941
 Vision, p.272
Barbourville, Kentucky, 1940

PREVOST, Victor (active in New
 York 1853-1857)
 Bradhurst Cottage on Blooming-
 dale Road near 148th Street,
 New York, occupied by Moli-
 neaux Bell, 1854, from a
 paper negative
 Taft, p.116
 Gurney's Daguerrean Gallery,
 349 Broadway, New York, 1854,
 waxed-paper process
 Taft, p.115

PRICE, William Lake (British,
 c.1810-1896)
 'Don Quixote' in His Study,'
 1855
 Coe, p.114
 Gernsheim-1, p.75
 Gernsheim-5, pl.102
 Hannavy, p.41
 "The 1st of September"
 V & A, pl.23
 Partridge (Dead Game), c.1855
 Gernsheim-1, p.89
 Gernsheim-5, pl.111
 Retour de Chasse (After the
 Hunt), stereo-card
 Jones, p.85

PRIMOLI, Count Giuseppe (Italian,
 1851-1927)
 Bedroom in Primoli's House,
 Rome, c.1895
 Kahmen, pl.120
 Edgar Degas, Coming out of a
 Pissoir, 1889
 Beaton, p.82
 Figurine Vendor outside the
 church of St. Agnese in the
 Piazza Navona, Rome, c.1890
 Kahmen, pl.117
 The Japanese doll, Rome, c.1898
 Maddow, p.478
 Portrait Study, c.1890
 Beaton, p.82
 Princess Mathilde Bonaparte
 with two Ladies-in-Waiting,
 1888
 Beaton, p.82
 Rejane and Admirers, 1889
 Beaton, p.83
 Rome, c.1890
 Maddow, p.479

PROESCH, Gilbert See GILBERT &
 GEORGE

PULHAM, Peter Rose (British)
 Christian Berard
 Beaton, p.30

PUYO, Emile Joachim Constant
 (French, 1857-1933)
 Montmartre, c.1900, gum print
 Beaton, p.125
 Gernsheim-5, pl.295
 Portrait en Sanguine, 1901,
 gum print
 Mathews, fig.235

QUICK, Herbert (1925-)
 Bath House, Elsinore, Califor-
 nia, 1951
 Lyons-1, p.79

QUINET, Achille
 The Parthenon, Paris, 1860s
 Scharf-2, p.130 (det.)
 View of Paris, c.1860
 Scharf-2, p.130

QUINN, Bill
 Mrs. Nikki Shuttleworth holds
 Shawnee Trade Mark, adjudged
 best-in-show...at the annual
 International Cat Show in the
 Garden, Sept.21, 1969 (Daily
 News)
 MOMA-4, p.37

RABETZ, Walter (Polish-American,
 1940-)
 Untitled, 1968
 Lyons-3, p.42

RAE, James (British)
 Family Group
 Hannavy, p.35

RAGINSKY, Nina (Canadian, 1941-)
 Reverend Noakes and Bentley,
 Suffolk, England, 1967
 Lyons-3, p.32

RAKOFF, Penny (American)
 Untitled

Beaton, p.234
Supporter of Dr. Nkrumah, 1960
Braive, p.357
U.S. Army, Vietnam, 1967
Pollack, p.471

RICALTON, James
Criminal Kneeling Over His Own
Grave-Japanese Executioner
Beheading a Condemned Chinese,
Tientsin, China, 1904, stereo-
card
Jones, p.111
A Tethered Captive in a Frenzy
of Rage, Ridgeway Kraal, 1902,
Ceylon
Jones, p.108

RICCIARDI, Mirella (Kenyan, 1933-)
Samburu women, Northern Frontier
District, Kenya, 1956
Beaton, p.248

RICE, Leland D. (American, 1940-)
Untitled, 1967
Lyons-3, p.83
Untitled, 1969
Doty-2, p.237
Untitled, 1971
Doty-2, p.237
Untitled (Barber Chair and
Couch), 1972
Wise, p.95
Untitled (Nude and Plant), 1972
Wise, p.91
Untitled (Door and Wall), 1973
Wise, p.94
Untitled (Girl and Fisherman),
1973
Wise, p.90
Untitled (Stick and Wall), 1974
Wise, p.92
Wall Series #3, Chair and Stick,
1974
Wise, p.93
Wall Series #11, Tripod and
Light, 1974
Wise, p.95
With You, 1969
Kansas, fig.45

RICHARD, Armand
(attributed to)
Princess Marie, c.1880
Coke, p.51

RICHARDS, Eugene (American,
1944-)
Anti-Bussing Rally, 1974
Wise, p.186
Chiaroscuro, 1968
Lyons-3, p.54
Dudley Street, Five and Ten,
1974
Wise, p.184
First Communion at St. Margaret's,
1973
Wise, p.188
Frankie of Humphrey Street, 1974
Wise, p.187
Nursing Home, 1973
Wise, p.189
Patricia's First Communion, 1973
Wise, p.188
Prayer to a Plane, 1974
Wise, p.189
Woman and Hearse, 1974
Wise, p.185

RICHARDSON, Benjamin (1834-1925)
The Actor Henry E. Dixey, c.
1875, albumen print, in colla-
boration with N. Sarony
Monsen, p.18

RICHE, Fran (American)
Family Sandwich
Hayes, pl.72

RIGER, Robert (American, 1924-)
Arcaro is Down, Belmont Stakes,
1959
Doty-2, p.218
Over the Top for Six, Washington
at New York, 1960
Doty-2, p.219
Sudden Death Game-Baltimore
Colts vs. New York Giants,
1959
MOMA-5, p.109
Willie Mays Steals Third, New
York at Brooklyn, 1955
Doty-2, p.218

RIIS, Jacob A. (Danish-American,
1849-1914)
Bandits' Roost, 59½ Mulberry
Street, 1888
Doherty, pl.4
Gernsheim-4, fig.127
Kahmen, pl.44
Pollack, p.301

Taft, p.215
Rembrandt Peale and his wife,
 prob.1859
 Taft, p.214
Self-Portrait, 1859 or 1860,
 stereoscope
 Taft, p.178
Self-Portrait, 1860
 Taft, p.217
Self-Portrait at Home
 Taft, p.217

SEMAK, Michael (Canadian, 1934-)
Ghanian hospital patient, 1967
 Lyons-3, p.95
Gypsy Man and Wife, Greece, 1962
 T-L-5, p.22
Italy, 1961
 T-L-3, p.126
Toronto Street Parade
 T-L-6, pp.104-05 (col.)

SENZER, John
Mannequin, 1971
 T-L-3, p.93

SESCAU, Paul
Double Portrait of Henri de
 Toulouse-Lautrec, c.1892
 Gernsheim-4, fig.112
Man and woman in a cafe, c.1890
 Coke, p.91

SEVENTY, Sylvia (American, 1947-)
Reflection 1, 1973, cyanotype on
 cotton
 Light, p.13

SEYMOUR, David See CHIM

SHAHN, Ben (Russian-American,
 1898-1969)
Amite, Louisiana, Oct.1935
 Vision, p.47
Arkansas, n.d.
 Doherty, pl.62
At a Fourth of July Celebration,
 Ashville, Ohio, 1938
 Thornton, p.134
Blind Street Musician, September
 1935
 Vision, p.15
Cattle dealer; West Virginia,
 1935
 Maddow, p.319
 Stryker, pl.33

Children of rehabilitation cli-
 ent, Maria Plantation, Arkan-
 sas, Oct.1935
 Vision, p.32
A citizen who has lost his farm
 and his sight and hearing;
 Circleville, Ohio, 1938
 Stryker, pl.15
Citizens of Columbus, Ohio,
 Aug.1938
 Vision, p.155
Clothing store window, Central
 Ohio, summer 1938
 Vision, p.152
Cotton Pickers at Work, Pulaski
 County, Arkansas, 1935
 MOMA-3, n.p.
 T-L-2, p.74
Cotton Pickers, Pulaski County,
 Arkansas, 1935
 T-L-2, p.75
Decorated Mailbox, Central Ohio,
 summer 1938
 Vision, p.46
Deserted mining town, Zinc,
 Arkansas, Oct.1935
 Vision, p.30
Destitute family, Ozark Moun-
 tains, Arkansas, 1935
 Hurley, p.29
FSA Rehabilitation Clients,
 Boone County, Arkansas, 1935
 T-L-2, p.72
Family of rehabilitation clients,
 Boone County, Arkansas, Oct.
 1935
 Vision, p.29
Interior of a blacksmith shop,
 Skyline Farms, Alabama, 1937
 Vision, p.121
Interior of Negro tenant farm-
 er's home, Louisiana, Oct.1935
 Vision, p.28
Linworth, Ohio
 Stryker, pl.118
Mailbox on farm, Central Ohio,
 summer 1938
 Vision, p.145
Man, Woman and Child, Smithland,
 Kentucky (A Young Family),
 1935
 T-L-2, p.73
 Thornton, p.135
Mechanicsburg, Ohio, 1938
 Stryker, pl.123
Medicine Show, Huntington, Ten-

Untitled, c.1935
 Doty-2, p.138
Waiting outside rural relief
 station, Urbana, Ohio (On
 Relief), 1938
 Hurley, p.51
 T-L-2, p.77
Watching the medicine show,
 Huntington, Tennessee, 1935
 Doherty, pl.60
 Maddow, p.318
Wife and child of a sharecrop-
 per; Ozark Mountains, Arkan-
 sas, 1935
 Stryker, pl.175
Wife and child of destitute
 Ozark Mountains Family, Ar-
 kansas, Oct.1935
 Vision, p.34
Wife and children of share-
 cropper, Muskgrove, Arkansas,
 Oct.1935
 Vision, p.33
Women, Crossville, Tennessee,
 1937
 Vision, p.133
Wonderbar, hot spot of Circle-
 ville, Ohio, summer 1938
 Vision, p.151
 (Photographs of Ben Shahn)
Ben Shahn, 1934, by L. Block
 Vision, p.44
Ben Shahn, Roosevelt, New
 Jersey, 1960, photographer
 unknown
 Vision, p.302

SHARPE, Geraldine (1929-)
 Child, Santa Cruz, California,
 1962
 Lyons-1, p.83

SHAW, George Bernard (Irish,
 1856-1950)
 Beatrice Webb, autochrome
 Scharf-1, fig.10.10 (col.)
 Portrait of Alvin Langdon Co-
 burn, pub.1906 in Camera Work
 Green, p.95
 (Photographs of G.B. Shaw--See
 Subject and Title Index)

SHAW AND JOHNSON
 Smith and Porter's Coffee House
 and Hotel, Sacramento and
 Sansome Streets, San Francis-

co, c.1850, daguerreotype
 Newhall-4, pl.83
 Rudisill, pl.53

SHEELER, Charles (American, 1883-
 1965)
 Blast Furnaces, Pittsburgh, 1952
 Coke, p.217
 Bucks County Barn, 1916
 Kahmen, pl.276
 Newhall-1, p.122
 Cactus and Photographer's Lamp,
 New York, 1931
 Coke, p.215
 Doty-2, p.111
 MOMA-1, p.107
 Ford Plant, River Rouge, 1927
 Pollack, p.255
 Funnel, 1927
 Lyons-1, p.18
 Generator, 1929
 Coke, p.214
 La Marseillaise, c.1926
 Pollack, p.254
 Stairwell, 1914
 Doty-2, p.98
 Kahmen, pl.277
 Newhall-1, p.123
 Wheels (Drive Wheels), 1939
 Coke, p.216
 MOMA-5, p.53
 Whitmaniana, c.1921
 Pollack, p.254
 Williamsburg Stairwell, 1935
 Beaton, p.172

SHEPHERD See BOURNE, SAMUEL AND
 SHEPHERD

SHEPHERD, Beth (American)
 Safed, Israel, 1972
 Hayes, pl.86

SHEPHERD, N. H.
 Abraham Lincoln, c.1847, da-
 guerreotype
 Newhall-4, pl.44

SHERE, Sam (1905-)
 The Hindenburg Disaster at Lake-
 hurst, New Jersey, 6 May 1937
 Gernsheim-4, fig.275

SHERIDAN, Sonia Landy (American,
 1925-)
 Untitled, 1971, carbon ironed-

off intermediate
SFMA, n.p.

SHEW, William (American, b.1820,
active 1840-1903)
 Kearny Street between Sacramento
 and California streets (looking
 north), San Francisco, 1852,
 daguerreotype
 Rudisill, pl.52
 Mother and Daughter, 1845-50,
 daguerreotype
 MOMA-1, p.15
 Placer mining near Hangtown,
 Calif., c.1851, daguerreotype
 Rudisill, pl.56
 San Francisco from Rincon Point,
 c.1852, panorama of 5 daguerre-
 otypes
 Newhall-4, pls.70-74
 San Francisco Harbor, 1852-53,
 daguerreotype
 MOMA-5, pp.72-73
 Unknown Man, c.1852, daguerreo-
 type
 Rudisill, pl.51
 (attributed to)
 The Traveling Daguerreotype
 Wagon of William Shew, San
 Francisco, 1851, daguerreotype
 Newhall-4, pl.82

SHINOYAMA, Kishin (Japanese)
 Birth, 1968
 T-L-5, p.137

SHIPMAN, Dru (American, 1942-)
 Untitled, 1972
 Wise, p.33

SHIRAKAWA, Yoshikazu (Japanese,
1935-)
 East Wall of Machapuchare Sum-
 mit, Himalayas, Nepal, c.1968
 Land, pl.15

SHORE, Stephen (American, 1947-)
 Deerfield Street, Greenfield,
 Massachusetts, 1974
 Topographics, p.37 (col.)
 Main Street, Gull Lake, Sas-
 katchewan, 1974
 Topographics, p.38 (col.)
 West Avenue, Great Barrington,
 Massachusetts, 1974
 Topographics, p.39 (col.)

SHORELL, Richard (1938-)
 Untitled, 1963
 Lyons-1, p.124

SHOSTAK, Marjorie (American)
 Male dancer with partner, Boston,
 Mass.
 Kalmus, p.86

SHRIVER, Robert (American)
 A Family Group, Sept.1860
 Taft, p.206

SICKERT, Walter (British, 1860-
1942)
 King George V talking to Major
 Featherstonhaugh at the Grand
 National, 1927
 Coke, p.100
 Man with beard, c.1927
 Coke, p.99
 The Servant of Abraham (study
 for), c.1929
 Coke, p.98
 (attributed to)
 Posed models for "The Raising of
 Lazarus", c.1927
 Coke, p.97
 Posed models for "Self-Portrait
 with Blind Fiddler"
 Coke, p.98

SIDEBOTHAM, J.
 (attributed to)
 James Nasmyth and His Steam
 Hammer, 1855
 Coe, p.92

SIEFF, Jeanloup (French, 1933-)
 Lying Nude, 1969
 T-L-5, p.134
 Untitled
 Beaton, p.250

SIEGEL, Arthur (American, 1913-)
 (From the series) "In Search of
 Myself", 1951
 Doty-2, p.197 (col.)
 Lucidogram #205, 1969
 Doty-2, p.225
 Photogram #189, 1936
 Doty-2, p.156
 Seascape-Photogram, 1964
 Newhall-2, n.p.
 Untitled
 Sixties, p.34

SMITH, W. Eugene (American,
 1918-)
 Burial at Sea, 1944
 T-L-2, p.158
 Country Doctor, 1948
 Pollack, p.613
 Cradle in a Packing Case
 Camera, p.43
 Dance of the Flaming Coke, 1956
 T-L-2, p.154
 Dr. Albert Schweitzer, Africa,
 1954
 Pollack, p.617
 Dr. Albert Schweitzer, Aspen,
 Colorado, 1949
 Newhall-2, n.p.
 Dr. Ceriani (Country Doctor),
 1948
 MOMA-1, p.151
 T-L-2, p.159
 Thornton, p.174
 Fawn, Africa, 1954
 T-L-2, p.155
 From My Window, New York, 1958
 T-L-1, p.210
 In the Garden of Eden (The Walk
 to Paradise Garden), 1946
 Camera, p.53
 Thornton, p.173
 Insane Compound, Dr. Schweitzer's
 Hospital, Africa, 1949 or 1954
 MOMA-5, p.48
 Newhall-2, n.p.
 Isle of Tortuga, Off Haiti, 1958
 T-L-1, p.209
 Japan (from Japan-a Chapter of
 Image)
 Pollack, p.614
 Japan (from Japan-a Chapter of
 Image), 1962
 Pollack, p.615
 T-L-1, p.208
 Japan (from Japan-a Chapter of
 Image)
 Pollack, p.615
 Juanita, 1953
 Doty-2, p.160
 Lambarene, 1954
 T-L-2, p.156
 Marine Holding Baby, Saipan,
 1943 or 1944
 Pollack, p.619
 Thornton, p.170
 Marine on Stretcher, Okinawa,
 1945
 Pollack, p.619

Mieko, n.d.
 T-L-2, p.160
Minamata-Tomoko and Mother
 (Tomoko in Her Bath), 1972
 Beaton, pp.204-05
 Doty-2, pp.162-63
 Kansas, fig.58
 Monsen, p.43
 Target, p.28
The Nurse-Midwife, South Caro-
 lina (Maude Callen, North
 Carolina), 1951
 Maddow, p.362
 Pollack, p.616
Pittsburgh Steel Worker (from
 "Pittsburgh, A Labyrinthian
 Walk"), 1955 or 1957
 Lyons-1, p.67
 Thornton, p.172
Pont Bedeau Hospital, 1958
 T-L-2, p.157
Saipan, 1944
 Thornton, p.171
The School Hallway, 1966
 Pollack, p.612
Sculptures by Elie Nadelman,
 1949
 T-L-1, p.211
Smoky City, Pittsburgh, 1955
 Pollack, p.611
Soldier Drinking, Saipan, 1943?
 Pollack, p.618
Spanish Village, 1950
 Pollack, p.621
Spanish Village: A Christening,
 1951
 T-L-6, p.79
Spanish Village: Death Scene,
 1950 or 1951
 Beaton, p.204
 Gernsheim-4, fig.261
 Maddow, p.363
 Pollack, p.621
Spanish Village: Dividing the
 Ground, 1951
 T-L-6, p.76
Spanish Village: Family Dinner,
 1951
 T-L-6, p.78
Spanish Village: First Communion
 Dress, 1951
 T-L-6, p.72
Spanish Village: Guardia Civil,
 1951
 T-L-6, p.78
Spanish Village: Haggling Over

Poet's House (First Version),
 1965
 MOMA-1, p.199
Quest of Continual Becoming,
 1965, combination photograph
 Lyons-4, p.50
Questioning Moment, 1971
 Coleman, pp.186-87
Ritual Ground, 1964
 Yale, n.p.
Ritual House, 1965, combination
 photograph
 Lyons-4, p.52
Self-Portrait, 1967
 Coleman, p.185
Simultaneous Implications, 1973
 Target, p.13
Untitled, 1963
 Lyons-1, p.136
Untitled, 1964, combination
 photograph
 Lyons-4, p.47
Untitled, 1964, combination
 photograph
 Lyons-4, p.49
Untitled, 1965, combination
 photograph
 Lyons-4, p.52
Untitled, 1965
 Lyons-4, p.46
 Sixties, p.37
Untitled, 1968
 Beaton, p.232
 Boston, pl.X
 Dennis, p.158
 Land, pl.48
Untitled, 1968
 T-L-3, p.153
Untitled, 1968
 Yale, n.p.
Untitled, 1968
 Doty-2, p.220
Untitled, 1969
 T-L-3, p.181
Untitled, 1969
 Yale, n.p.
Untitled, 1970
 Coleman, p.184
Untitled, 1970
 Coleman, p.187
Untitled, 1971
 Boston, pl.IX
Untitled, 1972
 Coleman, p.191
Untitled, 1972
 Coleman, p.192

Untitled, 1972
 Boston, pl.XII
Untitled, 1973
 Boston, pl.XI
Untitled, 1974
 Coleman, p.188
Untitled, 1974
 Coleman, p.188
Untitled, 1974
 Coleman, p.189
Untitled, 1974
 Coleman, p.190
Untitled, 1974
 Coleman, p.193
Untitled, 1974
 Thornton, p.219
Untitled (Hand and Bird), 1974
 Wise, p.23
Untitled (Owl), 1974
 Wise, p.22

ULMANN, Doris (American, 1884-
 1934)
 (From) The Portraits of Black
 People of the Gullah Region of
 South Carolina, 1925-34
 Maddow, p.327
 (From) "Roll, Jordon, Roll,"
 c.1930-32, photogravure
 Monsen, p.30
 (From) The Southern Appalachian
 Portraits, 1925-34
 Maddow, p.328
 (From) The Southern Appalachian
 Portraits, 1925-34
 Maddow, p.329
 Unidentified Sitter
 Beaton, p.140
 Untitled, c.1926, platinum print
 SFMA, n.p.

UMBEHR, Otto See UMBO

UMBO (Otto Umbehr) (German,
 1902-)
 Children for adoption. A visit
 to an adoption center in
 Berlin: In the dormitory, pub.
 1929
 Gidal, p.72
 Children for adoption. A visit
 to an adoption center in
 Berlin: The moment of parting,
 pub.1929
 Gidal, p.72
 Mine disaster: Listening for

WILSON, Jane
 Julia in the Park, 1964, Polar-
 oid
 Coke, p.220

WILSON, Tom Muir (American)
 Solarized Portrait, 1961
 T-L-5, p.124

WIMER, John A. (American)
 William Paul and Frederick
 David Langenheim, tinted
 daguerreotypes, in collabora-
 tion with William Langenheim
 Jareckie, p.5

WINANS, William A. (American,
 1943-)
 Multiple Series #4, 1968
 Lyons-3, p.131

WINNINGHAM, Geoffrey L. (American,
 1943-)
 After the Match (from Friday
 Night at the Coliseum, 1970)
 Thornton, pp.248-49
 Crowd at Ringside (from Friday
 Night at the Coliseum, 1970)
 Thornton, pp.244-45
 Fan with Photos (from Friday
 Night at the Coliseum, 1970)
 Thornton, p.244
 Miss Appaloosa Queen (from Going
 Texan), 1972
 Maddow, p.357
 Russian Chain Match (from Friday
 Night at the Coliseum, 1970)
 Thornton, p.247
 Tag Team Players (from Friday
 Night at the Coliseum, 1970)
 Thornton, p.246
 Wells Street #27, 1967
 Lyons-3, p.106
 Wrestler Greeting Crowd (Mil
 Mascaras in Defeat) (from
 Friday Night at the Coliseum,
 1970)
 Maddow, pp.358-59
 Thornton, pp.246-47

WINOGRAND. Gary (American, 1928-)
 Albuquerque (New Mexico), 1957
 Lyons-2, p.62
 UNC, pl.22
 Aquarium at Coney Island, 1963
 T-L-2, p.195

Austin, Texas, 1973
 Baltimore, p.69
Baboon, 1966
 T-L-5, p.180
Bronx Zoo, New York, 1959
 T-L-2, p.194
Central Park Zoo, New York City,
 1967
 Maddow, p.518
Coney Island, c.1960
 Lyons-1, p.117
Copenhagen, 1969
 Baltimore, p.67
 Target, p.22
Dallas, Texas, 1964
 T-L-2, p.193
Dressed Up for the Parade, Air
 Force Academy, Colorado, 1964
 T-L-2, p.197
Hollywood Boulevard, Los Angeles,
 1969
 T-L-2, p.192
Los Angeles, 1964
 Lyons-2, p.58
Los Angeles, 1964
 Lyons-2, p.64
New York City, 1959
 Lyons-2, p.67
New York City, 1960
 Lyons-2, p.66
New York City, 1968
 Baltimore, p.66
New York City, 1970
 Baltimore, p.68
New York World's Fair, 1964
 T-L-2, p.191
The Pet, 1962
 T-L-2, p.199
San Francisco, 1964
 Lyons-2, p.63
San Marcos, Texas, 1964
 Lyons-2, p.59
San Marcos, Texas, 1964
 Lyons-2, p.60
Soph-Frosh Rush, Columbia Uni-
 versity, 1950
 UNC, pl.47
Stanford, California, 1964
 Lyons-2, p.61
State Fair, Texas, 1973
 Maddow, p.517
Taxicab, London, 1969
 T-L-3, pp.138-39
Texas State Fair, 1964
 T-L-2, p.196
Texas State Fair, 1964

PART III
Subject and Title Index

Abbey of Montmajour, c.1852, by
 C. Negre
ABBOTSFORD, Roxburgh, Scotland
 Wilson, G.W. Abbotsford, 1886
ABERYSWYTH, Wales
 Bedford, F. Aberyswyth-The
 Castle, The Great Gate Tower
ABORIGINES
 Anonymous. King Billy and his
 wives, c.1856
 Eliosofon, E. Two Aboriginal
 Women of New Guinea, c.1960
ABRUZZI, Italy
 Cartier-Bresson, H. Abruzzi,
 1953
ABU SIMBEL, Egypt
 Du Camp, M. Colossus of Abu
 Simbel, Egypt, 1850
 Du Camp, M. Colossus of Abu
 Simbel, 1851
 Frith, F. Facade of the Temple
 of Rameses II at Abu Simbel,
 1857
 Frith, F. Rameses the Great,
 Abu Simbel, c.1856-57
 Frith, F. View of the Facade of
 the Great Rock Temple of Abou
 Simbel in Nubia, 1856
 Weber, W. Protecting the god's
 head with sand before lifting
 the Abu Simbel Temple,
 Southern Egypt
ADAMS, John
 Lee, R. John Adams, home-
 steader, drags ties down from
 mountains with burros to get
 cash for his farm, Pie Town,
 New Mexico, 1940

ADAMS, John Quincy
 Brady, M. John Quincy Adams,
 c.1847
 Haas, P. John Quincy Adams, 1843
 Southworth, A. and Hawes, J.J.
 John Quincy Adams, c.1852
ADOLF, Chris
 Lange, D. Rural rehabilitation
 client, portrait of Chris
 Adolf, Yakima Valley, Washing-
 ton, Aug.1939
AFGHAN WAR, 1878-1880
 Burke, J. Guns captured at Ali
 Musjid, 1878-79
 Burke, J. Officers of Her Majes-
 ty's 51st Regiment on Sultan
 Tarra, c.1879
AGAM, Yaacov
 Newman, A. Yaacov Agam, 1970
AGASSIZ, Louis
 Watkins, C.E. Louis Agassiz,
 c.1870
AGASSIZ COLUMN See YOSEMITE RIVER
 AND NATIONAL PARK
AGASSIZ PEAK, Arizona
 O'Sullivan, T. Mount Agassiz
 (Utah), c.1868
Agassiz Rock, near Union Point,
 1874, by C.E. Watkins
AGNELLI, Gianni
 Avedon, R. Signora Gianni Ag-
 nelli, 1953
AGNEW, Spiro
 Corkery, R. Joining hands at
 close of rally are Spiro Ag-
 new, Richard Nixon, George
 Romney, and Nelson Rockefeller,
 1968

Fitz, H. Probably a Street in
 Baltimore, c.1842-43
BALZAC, Honore de
 Anonymous. Honore de Balzac,
 c.1848
 Gavarni and Silvy. Balzac, c.1848
 Nadar. Balzac, c.1842
BANGS, F. C.
 Sarony, N. F.C. Bangs as "Sar-
 danapalus", c.1869-76
Baptismal Service; Morehead, Ken-
 tucky, 1940, by M. Post-Wolcott
BARA, Theda
 Hixon, O. Theda Bara, 1921
BARATTE, Marie
 MacNeil, W.S. Marie Baratte,
 1972-74
BARKERVILLE, Canada
 Dally, F. The French Hotel,
 Barkerville, 1868
BARNS See FARMS AND FARMING
BARNUM, P. T.
 Anthony, E. Barnum and an ac-
 tress, c.1860
BARRY, Jack
 Anonymous. Emcee Jack Barry
 bear hugs Charles Van Doren,
 Columbia instructor, after
 the latter won $104,500 on the
 TV-quiz show "Twenty-One",
 Jan.21, 1957
Bartender, Indiana, by S. Seed
BARTHOLOME
 Steichen, E. Bartholome, 1922
BARYSHNIKOV, Mikhail
 Swope, M. Mikhail Baryshnikov
BASEBALL
 Anonymous. The President Opens
 the Baseball Season in Wash-
 ington, April 20, 1924
 Anonymous. Led by "Lippy" Leo
 Durocher, the Gas House Gang
 argues with Umpire Dully
 Stark, May 21, 1937
 Anonymous. Manager helps his
 catcher in argument, July 31,
 1952
 Candido, P. Durocher #2 arguing
 with Ump Stewart, July 13,
 1941
 Froeber, L. Lippy vs. Libke,
 July 5, 1945
 Gora, R. Ah! There's the ball
 and alas there is also the
 beer, Oct.3, 1959
 Hurley, F. Ron looks like he's

 sorry, April 24, 1967
 Riger, R. Willie Mays Steals
 Third, New York at Brooklyn,
 1955
BASKETBALL
 Gellman, J.H. Bill Chamberlain
 Shooting, 1971
The Basket Maker, by P.H. Emerson
The Basketmaker, c.1865, anonymous
BASTION FALL See CATSKILL MOUN-
 TAINS
Bath House, Elsinore, California,
 1951, by H. Quick
BATHERS
 Anonymous. The Wave, c.1908
 Anonymous. On the Beach, c.1910
 Anschutz, T. Boys Swimming from
 a Single-Oared Scull, Phila-
 delphia, 1881
 Baldry, A.L. A Sea Frolic, c.
 1895
 Eliosofon, E. Bather in Tahitian
 Rapids, 1955
 Ellinger. Lake Balaton, Hungary,
 1907
 Hockney, D. Diving Man, c.1965
 Hoyningen-Huene, G. On the
 diving-board, c.1930
 Lartigue, J.H. The Diving of
 Cousin Jean, 1912
 Muray, N. Bathing Pool Scene for
 Ladies' Home Journal, 1931
 Sutcliffe, F.M. Water Rats, 1896
Bathtub, 1970, by S. Milito
BATS
 Leen, N. Dogfaced Bat, 1966
BAUDELAIRE, Charles
 Carjat, E. Charles Baudelaire,
 c.1861
 Carjat, E. Charles Baudelaire,
 c.1863
 Nadar. Charles Baudelaire, 1855
 Nadar. Charles Baudelaire, c.
 1856
 Nadar. Charles Baudelaire, 1859
 Nadar. Charles Baudelaire, 1860
BAYLEY, Eugenie
 Hill, L.L. Eugenie Bayley, c.
 1851
BAYLEY, William
 Anonymous. William Bayley, c.
 1862-65
 Carroll, L. William Bayley, c.
 1860-63
 Rejlander, O.G. William Bayley,
 c.1860-63

BRYCE CANYON, Utah
 Gilpin, L. Bryce Canyon No.2,
 1930
BUCHAREST, Rumania
 Angerer, L. The River Dimbovita,
 Bucharest, 1856
BUCKLEY, William F., Jr.
 Lopez, A. Vice President Hubert
 H. Humphrey and New York
 City's Conservative Party
 mayoralty candidate William
 F. Buckley, Jr., Oct.13, 1965
BUDBERG, Baron A. von
 Anonymous. Baron A. von Budberg
 and his family, 1859
BUFFALO, New York
 Anonymous. Ruins of the American
 Hotel, 1850
 Donnel. Ruins of the Hotel Amer-
 ica, March 1850
BUFFALO BILL See CODY, William
BUITENZORG, Java
 Woodbury, F. Village of Buiten-
 zorg (Java)
BULL-FIGHTERS AND BULL-FIGHTING
 Baubion-Mackler, J. Matador
 with Uncle
 Buckley, P. The Bull Attacks,
 Bilbao, 1951
 Buckley, P. Bullfight Critic,
 Logrono, 1956
 Buckley, P. Manoletina Pass,
 Bilbao, 1957
 Buckley, P. Matador Circling
 the Ring in Triumph, Bilbao,
 1956
 Haas, E. Bull Fighting
BUNTING, Reverend Jabez
 Hill, D.O. and Adamson, R. Rev.
 Jabez Bunting, c.1845
BUONAPARTE-GABRIELE, Princess
 Disderi, A.A.E. Princess Buona-
 parte-Gabriele, c.1862
BURGE, Sarah
 Anonymous. Sarah Burge, 1883
Burial at Sea, 1944, by W.E.
 Smith
BURNE-JONES, Edward
 Hollyer, F.H. The Burne-Jones
 and Morris Families, 1874
 Hollyer, F.H. Edward Burne-
 Jones and William Morris, 1874
BURNET, Janet
 Anonymous. Janet Burnet, 1893
BURNS, John L.
 O'Sullivan, T. John L. Burns

 with Gun and Crutches, 1863
BURRITT, Elihu
 Anonymous. Elihu Burritt, c.1850
BURROUGHS, Floyd
 Evans, W. Cotton sharecropper;
 Hale County, Alabama, 1935
BURROUGHS, William
 Avedon, R. William Burroughs,
 writer, New York City, 1975
BURTON, Richard
 Mitchell Tress, D. Richard
 Burton
Bus Boy, Paris, by I. Penn
Butcher, New York, by I. Penn
The Butterfly Collector, c.1850,
 anonymous
Butterfly Wings, 1840s, by W.H.F.
 Talbot
BYERLY, Jacob
 Anonymous. A daguerreotypist at
 work-Jacob Byerly of Frederick,
 Maryland, n.d.

CAERNARVON CASTLE
 Bedford, F. Caernarvon Castle,
 c.1860
 Bedford, F. Caernarvon Castle,
 c.1865
 Mudd, J. Caernarvon Castle,
 c.1855
CAIRO, Egypt
 Frith, F. Mosque of El-Hakim in
 Cairo, 1858
 Girault de Prangey, J.-P. Mosque
 of Kalaun, Cairo, 1842
CALDER, Alexander
 Newman, A. Alexander Calder,
 1957
CALDER, Billie
 Anonymous. Billie Calder,
 hanged Mar.16, 1900, in
 Lewistown, Montana
CALDER IDRIS See COES FAEN,
 Wales
CALEDON, Countess of
 Silvy, C. The Countess of Cale-
 don, c.1862
CALEDONIA SPRINGS, Ontario, Canada
 Topley, W.J. The Grand Hotel,
 Caledonia Springs, Ontario-
 'The Saratoga of Canada,' 1876
CALHOUN, John C.
 Brady, M. John C. Calhoun, c.
 1849

Bruce, Herbert Fisher, Edward,
Prince of Wales, Colonel Keb-
bel?, Oxford, 1858
Notman, W. Prince of Wales and
Suite at Montreal, Aug.1860
EDWARD VII, King of Great Britain
Anonymous. Edward VIII, c.1935
Munkacsi, M. The Prince of Wales
in his reception room in St.
James' Palace, London, pub.
1933
EDWARDS, Mississippi
Evans, W. Edwards, Mississippi
Evans, W. Main Street Store-
fronts, Edwards, Mississippi,
1936
Egg Slicer, 1930, by E. Weston
EHRENBERG, Christian Gottfried
Biow, H. Christian Gottfried
Ehrenberg, Chemist, Berlin,
1847
EINSTEIN, Albert
Doisneau, R. Albert Einstein
Halsman, P. Professor Albert
Einstein, 1948
Karsh, Y. Albert Einstein, 1948
EISENHOWER, Dwight David
Harris, G.W. and Ewing, M.
Dwight D. Eisenhower
EISENSTEIN, Sergei
Alvarez Bravo, M. Sergei Eisen-
stein, n.d.
Election Fever in Berlin, pub.
1932, anonymous
ELEPHANTS
Beard, P. Elephants, 1960
Eliosofon, E. A Herd of Elephants
Ricalton, J. A Tethered Captive
in a Frenzy of Rage, Rideway
Kraal, Ceylon, 1902
Rust. The State Elephant of a
Benares Rajah
ELIOT, Charles
Anonymous. Charles Eliot, n.d.
ELIOT, Ellsworth
Gurney, J. Ellsworth Eliot,
c.1852
ELIZABETH II, Queen of Great
Britain See also BRITISH ROYAL
FAMILY
Karsh, Y. Elizabeth II, 1951
The Elk, Cerfus Canadensis, 1871,
by W.H. Jackson
ELLSWORTH, Kansas
Gardner, A. A frontier town: the
main street of Ellsworth, Kan-

sas, Oct.1867
The Elopement, 1862, by L. Carroll
ELSIE, Lily
Foulsham and Banfield. Robert
Michaelis and Lily Elsie end-
ing The Dollar Princess
Martin, R. Lily Elsie
ELY, England
Evans, F. Ely Cathedral: A Mem-
ory of Normans, c.1900
ENGLEHARD, Georgia
Stieglitz, A. Georgia Engelhard,
1921
ENGELS, Jeanne
De Meyer, B.A. Jeanne Engels,
1921
ENSOR, James
Anonymous. James Ensor, c.1887
ERNST, Max
Brandt, B. Max Ernst, Paris,
1965
Newman, A. Max Ernst, 1942
ESKIMOS
Anonymous. Ou-se-Gong (Jeannie)
and Kud-Lup-Pa-Mune (Abbott),
1866-67
Anonymous. Eskimos, prob.1870
ETTY, William
Hill, D.O. and Adamson, R. Wil-
liam Etty, 1844
EUGENIE, Empress of France See
NAPOLEON III
EVERETT, Edward
Southworth, A.S. and Hawes, J.J.
Edward Everett, c.1848
EVERETT, Mary
White, C.H. Portrait of Miss
Mary Everett, 1908
EXETER, England
Sedgefield, W.R. The Old House
in the Close, Exeter, c.1859
EXPLORERS COLUMN See CANYON DE
CHELLY, Arizona
Eye with Tear, 1934, by M. Ray

FABRE, Jean Henri
Anonymous. An Interview with the
Naturalist Fabre, c.1908
'Fading Away,' 1858, by H.P. Rob-
inson
FAIRBAIRN, Reverend James
Hill, D.O. and Adamson, R. The
Reverend James Fairbairn and
Newhaven Fishwives, c.1854

FREEMAN, Henry
 Sutcliffe, F. Henry Freeman
FREMONT, John C.
 Brady, M. John C. Fremont, c.
 1850
 Brady, M. Major General Fremont,
 c.1864
FRIDH, Gertrude
 Winquist, R. Gertrude Fridh as
 Medea, 1951
FRISCH, Karl von
 Steinert, O. Karl von Frisch,
 1962
FRUIT See also STILL LIFES
 Atget, E. Fruit Stall, Rue
 Mouffetard, Paris, c.1910
 Caponigro, P. Fruit Bowl, 1964
 Caponigro, P. Pear, 1964
 Foucault, J.B.L. Grapes, c.1845
 Harris, K. Apple, c.1960
 Laurents, G. Pears in a Paris
 Window, 1961
 Milito, S. Pears, 1970
 Ray, M. Peach on Vine
 Schweitzer, M. Persimmons, 1959
 Steichen, E. Three Pears and an
 Apple, 1921
 Stieglitz, A. Apples and Gable,
 Lake George, 1922
 Sudre, J.-P. Dish with Straw-
 berries
 Turner, P. Cruets with a Lemon,
 1968
FUNERALS See also GRAVES AND
GRAVEYARDS
 Anonymous. Vigil by the Coffin,
 c.1848
 Brown, D. Martin Luther King
 Funeral, #1-17a, 1968
 Chim. Funeral of a Child, Italy,
 1948
 Hayes, D.B. Before Burial,
 Mexico
 Koudelka, J. Untitled (in Bea-
 ton, p.267)
 Lange, D. Funeral Cortege, End
 of an Era-in a Small Town,
 California, 1938
 Lebeck, R. Robert Kennedy
 Funeral, 1968
 Lyon, D. Funeral Renegades,
 Detroit
 Patellani, F. Funeral in Cala-
 bria, Italy, 1947
 Zabinski, R. Funeral, 1952
Funnel, 1927, by C. Sheeler

FURTWANGLER, Wilhelm
 Salomon, E. Wilhelm Furtwangler
 conducting in The Hague, 1932

GALENA, Illinois
 Hester, A. Levee at Galena,
 Illinois, 1852
GALITZKY, Thais
 Bragaglia, A.G. Thais Galitzky,
 1916
The Game of Cards, c.1902, anon-
ymous
A Game of Marbles, c.1902, anon-
ymous
GANDHI, Mahatma
 Bosshard, W. Gandhi eating onion
 soup, pub.1929-30
 Bosshard, W. Gandhi reading a
 satirical English poem about
 himself, pub.1930
 Bosshard, W. Gandhi taking a
 midday nap, pub.1929-30
 Bosshard, W. The man who chal-
 lenged the British Empire:
 Mahatma Gandhi reading, pub.
 1930
 Bourke-White, M. Mahatma Gandhi
 at a Spinning Wheel, 1946
 Cartier-Bresson, H. The first
 flame of Gandhi's funeral
 pyre, Delhi, 1948
GARBO, Greta
 Genthe, A. Greta Garbo, 1925
 Steichen, E. Garbo, 1928
GARDEN OF THE GODS, Colorado
 Chamberlain, W.G. Garden of the
 Gods, Colorado, No.109, c.1869
 Chamberlain, W.G. Monument Creek,
 Garden of the Gods, Colorado,
 No.110, c.1869
 Jackson, W.H. Balanced Rock,
 Garden of the Gods, after 1880
 Jackson, W.H. Gateway, Garden of
 the Gods and Pike's Peak,
 after 1880
 Jackson, W.H. Tower of Babel,
 Garden of the Gods (Colorado),
 after 1880
GARDINER RIVER, Montana
 Jackson, W.H. Crater of the
 Beehive Geyser, the Great Hot
 Springs on Gardiner's River
 (Wyoming), 1872
 Jackson, W.H. Hot Springs on

JOHN, Augustus
 Eisenstaedt, A. Augustus John,
 1951
JOHNSON, Lyndon
 Anonymous. President Johnson
 signing a bill, 1965
 Anonymous. President Johnson
 signing the Medicare bill...,
 July 30, 1965
JOHNSON, Mary
 Matthews, K. Mary Johnson, c.
 1900
JOHNSTONE, Elizabeth
 Hill, D.O. and Adamson, R.
 Elizabeth Johnstone, the
 Beauty of Newhaven Village,
 c.1845
JOHNSTONE, Justine
 Cecil, H. Justine Johnstone,
 c.1928
JOHNSTONE, W. B.
 Hill, D.O. and Adamson, R. D.O.
 Hill and W.B. Johnstone, c.1845
JONES, Carmen
 Mili, G. Carmen Jones, 1951
JONES, Reverend Thomas Henshaw
 Hill, D.O. and Adamson, R. Rev.
 Thomas Henshaw Jones, c.1845
JOPLIN, Janis
 Snyder, J. Janis Joplin
JOUFFROY, Francois
 Adam-Salomon, A.S. The Sculptor
 Jouffroy, c.1858
JOYCE, James
 Abbott, B. James Joyce, 1928
 Abbott, B. James Joyce, Paris,
 1920
Juggler, 1958, by G. Mili
The Juggler, c.1855-61, by O.G.
 Rejlander
JUI-LIN
 Thomson, J. Jui-Lin, Governor
 General of the two Kwang
 Provinces, 1873-74

KAFKA, Franz
 Anonymous. Franz Kafka, 1918
KAHNWEILER, Daniel
 Brassai. Daniel Kahnweiler, 1962
KAMAKURA, Japan
 Beato, F.A. Kamakura, Japan,
 c.1862-67
Kangeroo Jumping, c.1885, by E.
 Muybridge

KANOVITZ, Howard
 Anonymous. Howard Kanovitz and
 his wife, 1965
KARDASSY, Nubia
 Du Camp, M. Temple of Kardassy,
 Nubia, 1850
KARDORF-OHEIMB, Katharina von
 Salomon, E. Two Women Politici-
 ans in 1930: Katharina von
 Kardorf-Oheimb and Ada Schmidt
 -Beil
KARNAK, Egypt See also LUXOR
 Horeau, H. Thebes: Hypostyle
 Hall, Karnac, pub.1841
 Smith, J.S. Relief on a Temple
 at Thebes, 1851
KARR, Alphonse
 Adam-Salomon, A.S. Alphonse
 Karr, c.1867
KARSAVINA
 Park, B. Karsavina
KASAN, Russia
 Anonymous. Kasan, Russia, c.1870
KASHMIR, India
 Bourne, S. The Dhul Canal, 1864
KELLER, Helen
 Marshall. Helen Keller and Annie
 M. Sullivan, c.1905
KELLEY, Kathleen
 Welpott, J. Kathleen Kelley,
 1972
Kelmscott Manor, 1896, by F. Evans
Kelmscott Manor, Attics, c.1897,
 by F. Evans
Kelp, 1964, by G.H. Robinson
Kelp, Point Lobos, 1940, by E.
 Weston
KEMP, George Meikle
 Hill, D.O. and Adamson, R.
 George Meikle Kemp, architect
 of Sir Walter Scott Monument,
 Edinburgh, 1844 or earlier
KENNEDY, Jacqueline See ONASSIS,
 Jacqueline Kennedy
KENNEDY, John Fitzgerald
 Bernheim, M. and E. Kennedy
 Cloth, Ivory Coast, 1964
 Capa, C. President John Fitz-
 gerald Kennedy, 1962
 Friedlander, L. Kennedy Memori-
 al, 1964
 Harris, G.W. and Ewing, M. John
 F. Kennedy
 Larsen, L. Kennedy Wedding, 1953
 Schutz, R.H. Father and Son,
 Otis Air Force Base, 1963

n.d.
Wilson, C.A. Oxford Street, London, 1887
Wilson, G.W. Greenwich Pier, 1857
Wilson, G.W. Regent Street, London
LONG DOG See INDIANS
LONGFELLOW, Henry Wadsworth
Anonymous. Henry Wadsworth Longfellow and his daughter in Rome, 1868-69
Cameron, J.M. The Poet Henry Longfellow, 1870
Whipple, J.A. Henry Wadsworth Longfellow, American Poet, c. 1850
Lookout Mountain, Tennessee, c. 1860-65, anonymous
LOPEZ, Juan
Collier, J. Juan Lopez, the mayor of the town, Trampas, New Mexico, Jan.1943
LOPEZ, Maclovia
Collier, J. Maclovia Lopez, wife of the mayor, spinning wool by the light of the fire, Trampas, New Mexico, Jan.1943
LOREN, Sophia
Avedon, R. Sophia Loren, 1970
LORRE, Peter
Jacobi, L. Peter Lorre, Berlin, 1930s
LOWESTOFT, England
Barrett, M. The Inner Harbour, South Quay, c.1860
LOY, Mina
Lynes, G.P. Myna Loy, 1931
LOZOWICK, Louis
Steichen, E. Louis Lozowick, 1929
LUCKNOW, India See INDIAN MUTINY OF 1857
LUDLAM, Charles
Tress, A. Charles Ludlam, Punchman, 1975
LUXOR, Egypt See also KARNAK
Frith, F. Hypostyle Hall, Luxor, Egypt
Frith, F. The Landing Place, Luxor, 1857
Horeau, H. Luxor, pub.1841
Smith, J.S. Pillars of the Great Hall of the Temple of Karnak, Luxor, 1851
Luxury, n.d., anonymous

LYDIG, Mrs. Philip
Steichen, E. Cyclamen-Mrs. Philip Lydig, pub.1913
LYDSTEP, Wales
Bedford, F. Lydstep, Wales-The Natural Arch, c.1865
LYMAN, Mr. and Mrs. Andrew
Delano, J. Mr. and Mrs. Andrew Lyman, Polish Tobacco Farmers Near Windsor Locke, Conn., 1940
LYNCH, Alfred
Dominic, Z. Alfred Lynch in Waiting for Godot, 1964
Lynching in Mississippi, 1935, anonymous
LYONS, France
Lumiere, L. Lyons in the Snow, c.1908

MAAR, Dora
Ray, M. Dora Maar, c.1936
McCLANDISH, Margaret
Hill, D.O. and Adamson, R. Miss Margaret McClandish and Her Sister, c.1845
McCOMBE, Leonard
Eisenstaedt, A. Leonard McCombe, 1964
MacDONALD, Irene
Carroll, L. 'It Won't Come Smooth,' 1863
MacDONALD, John A.
Anonymous. John A. MacDonald, Attorney-General for Canada West, c.1857
Ellisson and Co. John A. MacDonald, c.1863
Ewing, R.D. Sir John A. Macdonald, First Prime Minister of the Dominion of Canada, c.1870
MacDONALD, Ramsey
Salomon, E. Stanley Baldwin and Prime Minister Ramsey MacDonald During a Press Conference, London, Sept.1931
McDOUGALL, William
Ellisson and Co. William McDougall, Reform Politician, c.1860
MACDOWELL, Mary
Eakins, T. Mary Macdowell, c. 1886
MACDOWELL, William H.
Eakins, T. William H. Macdowell,

1891
Mayberry, J.H. Miners at Bloody
 Gulch, c.1880
O'Sullivan, T. At Work in the
 Gold and Curry Mine, Virginia
 City(?), 1868
O'Sullivan, T. Interior of the
 Gould and Curry Mine (Nevada),
 1868
O'Sullivan, T. Interior of the
 Savage Mine (Nevada), 1868
O'Sullivan, T. Savage Mine,
 Curtis Shaft (Nevada), 1868
Ronis, W. Mechanisation in the
 Mines of Alsace
Shew, W. Placer Mining Near
 Hangtown, Calif., c.1851
Smith, W.E. Welsh Miner, 1950
Umbo. Mine Disaster, pub.1932
Vance, R.H. View of Poverty Bar
 to Oregon Bar. River-Bed Min-
 ing in California, 1859
MINNEAPOLIS, Minnesota
Anonymous. Indian village on the
 site of Bridge Square and
 house of Col. John Stevens,
 1854
Anonymous. First bridge across
 the Mississippi River, opened
 July 4, 1855, 1855-56
MIRAMON, General
Anonymous. General Miramon, n.d.
MIRO, Joan
Karsh, Y. Joan Miro, 1965
MITLA, Mexico
Charnay, D. The Grand Palace at
 Mitla, c.1859
The Modoc War: Camp South from
 Signal Tower, Tule Lake in dis-
 tance, 1873, by E. Muybridge
MONCK, Lord
Ellisson and Co. Lord Monck,
 c.1863
MONDRIAN, Piet
Kertesz, A. Mondrian's Studio,
 Paris, 1926
Kertesz, A. Piet Mondrian, Par-
 is, 1926
Newman, A. Piet Mondrian, 1942
MONET, Claude
Muray, N. Claude Monet, 1926
Muray, N. Claude Monet in his
 garden
MONIER-WILLIAMS, Ella
Carroll, L. Ella Monier-Williams,
 1866

MONKS See also PRIESTS
Annan, J.C. A Franciscan, Venice,
 c.1895
Annan, J.C. The White Friars,
 1896
Bosshard, W. Kumbum, the city
 of three thousand monks in
 China, pub.1934
Gluck, B. Coconut Monk Disciple,
 Phoenix Island, Vietnam, 1973
Kertesz, A. Lay brothers at
 mass, Notre Dame de la Grande
 Trappe, Soligny, pub.1929
Kertesz, A. Mealtime-the monks
 are vegetarians, Notre Dame
 de la Grande Trappe, Soligny,
 pub.1929
Kertesz, A. The monks' dormi-
 tory, Notre Dame de la Grande
 Trappe, Soligny, pub.1929
Kertesz, A. Monks on the way to
 mass, Notre Dame de la Grande
 Trappe, Soligny, pub.1929
Kertesz, A. When one of the
 brothers dies, a three-day
 vigil is kept by the coffin,
 Notre Dame de la Grande Trappe,
 Soligny, pub.1929
Lange, D. Feet of Monk, Burma,
 1958
Thomson, J. Greek Monks, St.
 Pantalemoni, Cyprus, 1878
MONNIER, Henri
Carjat, E. Henri Monnier, pub.
 1878
Disderi, A.A.E. Henri Monnier,
 c.1860
Nadar. Henri Monnier, c.1860
MONO LAKE, California
Adams, A. Mono Lake, California,
 1944
O'Sullivan, T. Volcanic Islands,
 Mono Lake, California, c.1868
Weston, B. Mono Lake, Califor-
 nia, 1957
MONROE, Marilyn
Stern, B. Marilyn Monroe, 1962
Straus, E. Heat Waived? (Marilyn
 Monroe), June 21, 1949
Weegee. Marilyn Monroe, c.1953
MONSEN, Elaine
Newman, A. Elaine and Joseph
 Monsen, 1975
MONSEN, Joseph
Newman, A. Elaine and Joseph
 Monsen, 1975

350

PHOTOGRAPHY INDEX

PUVIS DE CHAVANNES, Pierre
 Carjat, E. Puvis de Chavannes,
 1878
PYLE, Ernie
 Eisenstaedt, A. Ernie Pyle, the
 GI's Favorite War Reporter,
 1944
PYRAMID LAKE, Nevada
 O'Sullivan, T. Pyramid Lake,
 Nevada, 1868
 O'Sullivan, T. Rock Formations,
 Pyramid Lake (Nevada), 1868
 O'Sullivan, T. Tufa Rocks, Pyra-
 mid Lake (Nevada), 1868
PYRAMIDS See GIZA, Egypt

Quaker Sisters, c.1850, anonymous
QUEBEC, Canada
 England W. Ship Building and
 Loading Timber at Wolfe's
 Cove, Quebec, 1859
 Notman, W. Arch on John St.,
 Aug.1860
 Vallee, L.P. Break-Neck Steps,
 Quebec, c.1870
 Vallee, L.P. Champlain Wharf,
 Quebec, c.1870
 Vallee, L.P. Convalescent Ward,
 Hotel-Dieu, Quebec, c.1875
 Vallee, L.P. Hope Gate, Quebec,
 prob.1867
 Vallee, L.P. Upper Town Market
 in Winter, Quebec, c.1870
QUETZALTENANGO VOLCANO, Guatemala
 Muybridge, E. Quezaltenango,
 Crater of the Volcano, Guate-
 mala, 1875
 Muybridge, E. Volcano Quetzal-
 tenango, Guatemala, 1875
QUINNEY, Adele See INDIANS

RAILROADS See TRAINS
RANAVALONA II, Queen of Madagascar
 Anonymous. Ranavalona II, Queen
 of Madagascar, 1882
RAPP, Marie
 Stieglitz, A. Portrait of Marie
 Rapp, 1916
RAUCH, Christian
 Schwartz, C. Christian Rauch,
 1852

RAY, Gabrielle
 Downey, W. and D. Gabrielle Ray
READE, Reverend J. B.
 Maull and Polyblank. Rev. J.B.
 Reade, F.R.S., c.1856
RED-ARMED PANTHER See INDIANS
Refugee Camp, Punjab, India, 1947,
 by H. Cartier-Bresson
REIMS, France
 Marville, C. Treasure of Reims
 Cathedral, 1854
REINDEER
 Andersson, G. Reindeer Herd
 Nilsson, P.-N. Reindeer in the
 Mountains, Mittadalen, North
 Sweden, 1964
REJANE
 Nadar. Rejane
 Primoli, G. Rejane and Admirers,
 1889
RENOIR, Auguste
 Anonymous. Auguste Renoir, n.d.
 Degas, E. Renoir and Mallarme,
 c.1883
RESTAURANTS
 Frank, R. Restaurant-U.S.1,
 Leaving Columbia, South Caro-
 lina, 1955
 Michals, D. Restaurant Booth,
 1964
RHINOSCEROS
 Maxwell, M. The second ball
 makes it spin round and col-
 lapse on its forelegs, c.1923
 Mills, C. Rhodesia's most famous
 orphan-Rupert the rhino, n.d.
 Schack, W. Rhinosceros Herd,
 1953
 Vetter, E. Rhinosceros
RICHMOND, Virginia
 Anonymous. Ruins of Richmond,
 Virginia, April 12, 1865
 Brady, M. The Ruins of Richmond,
 Va., April 1865
 Brady, M. Ruins of the Gallego
 Flour Mills, burned April
 23rd, 1865
 Levy and Cohen. Richmond, Vir-
 ginia, June 1865
RICKETTS, General
 Brady, M. General Ricketts and
 wife, c.1855
RIEL, Louis
 Buell, O.B. Riel Addressing the
 Jury in Court-House, Regina,
 1885

RUTHVEN, Lady Mary
Hill, D.O. and Adamson, R. Lady
Mary Ruthven, c.1848
RUYL, Beatrice Baxter
Kasebier, G. The War Widow, n.d.
RYE, England
Evans, F. Rye, c.1900-15

SACCO, Nicola
Anonymous. Bartolomeo Vanzetti
and Nicola Sacco, 1921
Anonymous. Bartolomeo Vanzetti
and Nicola Sacco in the pri-
soner's dock, 1921
Saco Valley, from Willey Brook
Bridge, P. & O. R.R., White
Mountains, N.H., by N.W. Pease
SAHARA DESERT
Rodger, G. The Great Western
Erg, Algerian Sahara, 1957
SAILORS See SEAMEN
SAINT ANDREWS, Scotland
Hill, D.O. and Adamson, R. St.
Andrews Harbor, c.1846
Hill, D.O. and Adamson, R. St.
Andrews, Ruin of Castle and
Sea, c.1845
Hill, D.O. and Adamson, R. St.
Salvator's Church, St. Andrews
SAINT ANTHONY FALLS, Minnesota
Anonymous. St. Anthony Falls
(looking east) and St. Antho-
ny (now part of Minneapolis),
Minn., c.1852
Anonymous. St. Anthony Falls
(looking west) and bridge over
secondary branch of the Missis-
sippi River, c.1854
Anonymous. St. Anthony Falls
(looking east-reversed image)
and St. Anthony, Minn., c.1855
Anonymous. Suspension Bridge of
St. Anthony, opened Jan.27,
1855
Hesler, A. St. Anthony Falls on
the Mississippi River (looking
east), Aug.1851
Whitney, J.E. St. Anthony Falls
(looking West), July 1852
SAINT JOHN, New Brunswick, Canada
Climo, J.S. Germain St. Baptist
Church After the Great Fire,
n.d.
McClure, J. After the Great

Fire of 20 June 1877
Notman, J. Market Slip, Saint
John, N.B., early 1870s
SAINT LOUIS, Missouri
Anonymous. St. Louis Levee, c.
1855
Easterly, T.W. Lynch's Slave
Market
SAINT MALO, France
Renger-Patzsch, A. Breakwater at
St. Malo, Brittany, 1942
SAINT MICHEL, Mont See MONT ST.
MICHEL, France
SAINT PAUL, Minnesota
Anonymous. Hardware Store of J.
McCloud, Jr., c.1851
Anonymous. Founding Chapel of
St. Paul, built by Fr. Lucien
Galtier in 1841, 1854
Anonymous. Le Duc House and
Book Store, Wabasha and Second
Streets, St. Paul, Minn., c.
1855
Anonymous. St. Paul, Minn., c.
1855
Gohlke, F. Landscape, St. Paul,
1974
ST. VICTOR, Niepce de
Anonymous. Niepce de St. Victor,
c.1848
SAINTE-AGNES-EN-PROVENCE, France
Olson, L. View of Ste.-Agnes-en-
Provence
Saloon, Beowawe, Nevada, 1940, by
A. Rothstein
SALT LAKE CITY, Utah
Cannon, M. Ground-breaking cere-
monies for the Mormon Temple,
Feb.14, 1853
O'Sullivan, T. Salt Lake City,
c.1868
Savage, C.R. Salt Lake from
Prospect Hill, c.1886
Watkins, C.E. Salt Lake City
from Arsenal Hill, c.1872
Salt Lake Valley, Utah, before
1870, by A.J. Russell
SALZMAN, Alexander de
Steichen, E. Alexander de Salz-
man, New York, 1932
Samburu women, Northern Frontier
District, Kenya, 1956, by M.
Ricciardi
SAN FRANCISCO, California
Anonymous. San Francisco, Look-
ing Northeast toward Yerba

SPANISH-AMERICAN WAR
 Lazarnick, N. U.S. Troops, Span-
 ish-American War, 1898
SPANISH CIVIL WAR
 Capa, R. Death of a Loyalist
 Soldier, 1936
 Capa, R. Spain, 1936
 Capa, R. This Is War!, 1938
 Chim. Barcelona Air Raid, 1936
 Chim. Loyalist Troops, 1936
 Smith, W.E. Wounded in the
 Church (Spain)
SPARTALI, Marie
 Anonymous. Marie Spartali, c.
 1870-75
 Cameron, J.M. Marie Spartali,
 c.1868
 Cameron, J.M. Marie Spartali,
 c.1870
 Rejlander, O.G. Possibly Marie
 Spartali, c.1865-68
Speakeasy, 1931, by M. Bourke-
 White
Sperm Cells Englarged About 15,000
 Times, by L. Nilsson
SPHINX See GIZA, Egypt
Spider's Web; in the background,
 the Villa Malcontenta, by Lord
 Snowdon
STALIN, Ekaterina See DZHUGASH-
 VILI, Ekaterina
STANLEY, John M.
 Anonymous. John M. Stanley, n.d.
STANLEY, Kim
 Newman, A. Kim Stanley, 1963
STANLEY, Pamela
 McBean, A. Pamela Stanley as
 Queen Victoria, 1938
The Steerage, 1907, by A. Stieg-
 litz
STEIN, Gertrude
 Beaton, C. Gertrude Stein and
 Alice B. Toklas, c.1940
STEINBERG, Saul
 Doisneau, R. Saul Steinberg,
 1953
 Morath, I. Saul Steinberg
STENLUND, Frank
 Runk, J. Pine Boards and Frank
 Stenlund, South Stillwater
 (now Bayport), Minnesota, 1912
STEPHEN, Leslie
 Beresford, G.C. Leslie Stephen
 and his daughter Virginia
 (Woolf), c.1902
STEPHEN, Mrs. Leslie See DUCK-

WORTH, Julia Jackson
STEPHENSON, Robert
 Maull and Polyblank. Robert
 Stephenson, 1856
STEVENS, Alexander H.
 Brady, M. Alexander H. Stevens,
 Vice President of the Confed-
 eracy, n.d.
STEVENS, John
 Hill, D.O. and Adamson, R. The
 Sculptor John Stevens and
 Bust of Lucius Verus, 1843-45
STEVENS, Mrs. John H.
 Anonymous. Mrs. John H. Stevens
 and daughter Mary Elizabeth,
 c.1852
STEVENS, Mary Elizabeth
 Anonymous. Mrs. John H. Stevens
 and daughter Mary Elizabeth,
 c.1852
STEVENSON, Robert Louis
 Smith, A.G.D. Robert Louis
 Stevenson, c.1889
STIEGLITZ, Emmeline
 Eugene, F. Emmeline Stieglitz,
 1907
STIEGLITZ, Kitty
 Eugene, F. Kitty Stieglitz, 1907
STILL LIFES See also FLOWERS;
 FOOD; FRUITS; PLANTS AND VEGE-
 TABLES
 Anonymous. Still-Life, c.1870-75
 Bayard, H. Statuary Still-life,
 c.1840
 Bayard, H. Still-Life, 1839
 Bayard, H. Still-Life, c.1845
 Bayard, H. Still life: collection
 of casts, June 1840
 Carpenter and Westley. Still-
 life, c.1853
 Claudet, A.J.F. Still-Life in
 Attic, mid-1850s
 Cosindas, M. Still Life, 1967
 Cosindas, M. Still Life with
 Asparagus, 1967
 Daguerre, L.J.M. The Artist's
 Studio, 1837
 Daguerre, L.J.M. Still Life
 De Meyer, B.A. Still Life, c.
 1907
 Diamond, H.W. Still-Life, 1850s
 Duboscq, L.J. Still life of
 skull, crucifix and hourglass,
 c.1852-54
 Fenton, R. Fruit, Flowers and
 Parisian Vase

Post-Wolcott, M. Washington,
D.C., 1941
Water Skier, by E. Haas
WATTS, George Frederick
Cameron, H.H. G.F. Watts, c.1892
Cameron, J.M. G.F. Watts, 1864
Cameron, J.M. The Whisper of the
Muse, c.1866
Steichen, E. The Painter George
Frederick Watts, 1901
WEBB, Captain
Anonymous. Captain Webb, the
swimmer, n.d.
WEBB, Beatrice
Shaw, G.B. Beatrice Webb
WEBER RIVER VALLEY, Utah
Russell, A.J. Weber Valley from
Wilhelmina Pass (Utah), 1867/
68
WEBSTER, Daniel
Anonymous. Daniel Webster sitting
outdoors at his Marshfield,
Massachusetts, home, c.1848
Brady, M. Daniel Webster
Langill, H.H.H. Daniel Webster,
c.1852
Southworth, A.S. and Hawes, J.J.
Daniel Webster, c.1850
WEDDINGS
Anonymous. A Wedding, n.d.
Akiyama, R. Newlyweds after
Planting Memorial Trees on the
Slope of a Mountain, Kagoshi-
ma, 1970
Arbus, D. A flower girl at a
wedding, Connecticut, 1969
Davidson, B. Marriage in Wales,
1961
Freed, L. Hassidic Wedding, New
York City
Fukase, M. Yohko, 1964
Garrett, B. Daughter Jennie as
a Bride, 1969
Gold, L.F. Wedding in Brooklyn
Harbutt, C. Bride in Cellar,
1966
Klein, S. Molly and Hanks' Wed-
ding
Koga, M. Hutterite Bride, June
1972
Lopez, J. Puerto Rican Brides-
maid, Chicago, 1972
Mark, M.E. Wedding Day, 1965
Mayall, J.J.E. Wedding Guests,
taken the day before the wed-
ding of the Prince of Wales

and Princess Alexandra of Den-
mark, 9 March 1963
Michals, D. Newlyweds, 1967
Milito, S. The Wedding
Munkacsi, M. Wedding Celebration
in the house of Mustafa Kemal
Pasha in Ankara, pub.1934
Suris, S. Orthodox Jewish Wed-
ding Ceremony in the Rain
Van DerZee, J. Wedding Day,
Harlem, 1925
Williams, T.R. Princess Royal's
Bridesmaids, 1858
WELLS, Nancy
Gowin, E. Nancy Wells, Danville,
Virginia, 1969
WELLS, England
Evans, F. A Sea of Steps (Chap-
ter-house interior, Wells
Cathedral), 1903
WENTWORTH, John
Anonymous. John Wentworth, 1847
WERNER, Oskar
McLaughlin-Gill, F. Oskar Werner
West Stockbridge, Massachusetts,
1841-42, by A. Clark
WHEELER, Ethel
Evans, F. Ethel Wheeler, n.d.
WHITBY, England
Sutcliffe, F. Barry's Square,
the Crag, Whitby
Sutcliffe, F. Whitby Harbour,
c.1900
WHITE, Maria
Carroll, L. Maria White, 1864
WHITLEY, R. B.
Post-Wolcott, M. Mr. R.B. Whit-
ley visiting his general
store, Wendell, Wake County,
North Carolina, Sept.1939
WHITMAN, Mrs. Joseph Elisha
Anonymous. Mrs. Joseph Elisha
Whitman and Her Son Joseph
Elisha Jr., born 1853
WHITMAN, Walt
Brady, M. Walt Whitman, before
1861
Brady, M. Walt Whitman, c.1870
Eakins, T. Walt Whitman, second
floor bedroom in Whitman's
Camden house
Harrison, G. Walt Whitman, c.
1855
WHITTLESEY, Thurlow Weed
Anonymous. Thurlow Weed Whit-
tlesey and friends, c.1850

About the Compiler

Pamela Jeffcott Parry is the editor of the Art Libraries Society
of North American Newsletter. She is the compiler of *Con-
temporary Art and Artists: An Index to Reproductions* (Green-
wood Press, 1978).